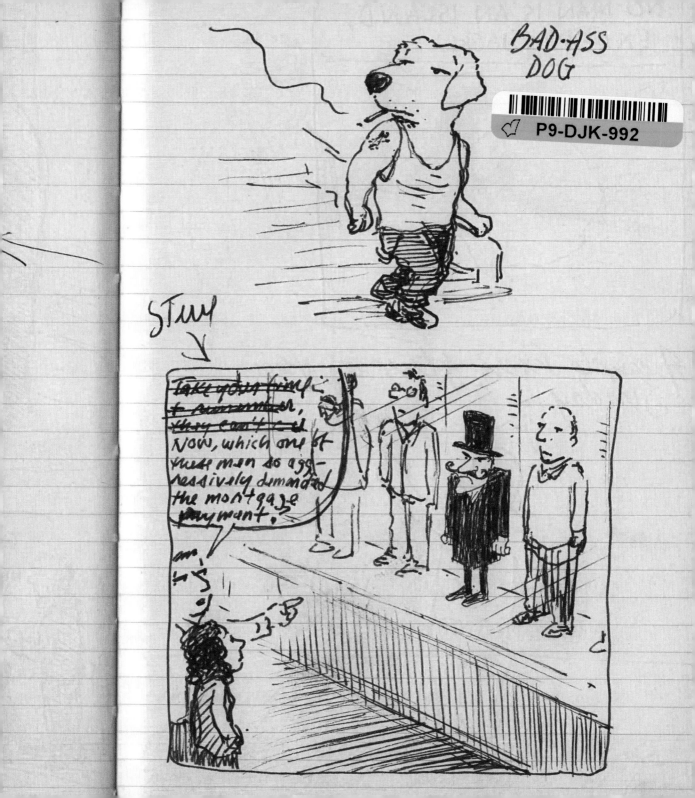

WEALTHY FAMILIES YOU DON'T KNOW ABOUT

Janice + Irving Ping-Pong

Clarissa + Ethel Bungee

Mariam + Jules Kibble

The Umbrellas of Nyack

A
Wealth
of Pigeons

A Wealth

A Cartoon

of Pigeons

Collection by

Harry Bliss

and

Steve Martin

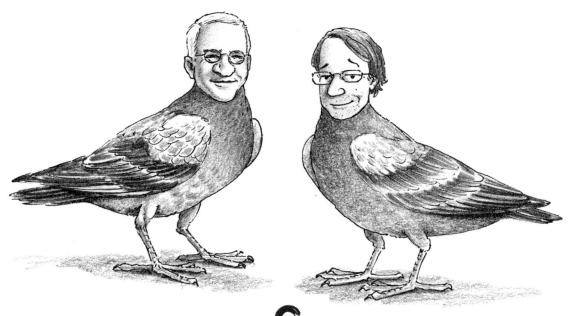

C

CELADON
BOOKS

NEW YORK

A WEALTH OF PIGEONS. COPYRIGHT © 2020 BY STEVE MARTIN AND HARRY BLISS. ALL RIGHTS RESERVED. PRINTED IN THE UNITED STATES OF AMERICA. FOR INFORMATION, ADDRESS CELADON BOOKS, A DIVISION OF MACMILLAN PUBLISHERS, 120 BROADWAY, NEW YORK, NY 10271.

WWW.CELADONBOOKS.COM

THE LIBRARY OF CONGRESS CATALOGING-IN-PUBLICATION DATA IS AVAILABLE UPON REQUEST.

ISBN 978-1-250-26289-9 (HARDCOVER)
ISBN 978-1-250-78235-9 (SIGNED EDITION)

OUR BOOKS MAY BE PURCHASED IN BULK FOR PROMOTIONAL, EDUCATIONAL, OR BUSINESS USE. PLEASE CONTACT YOUR LOCAL BOOKSELLER OR THE MACMILLAN CORPORATE AND PREMIUM SALES DEPARTMENT AT 1-800-221-7945, EXTENSION 5442, OR BY EMAIL AT MACMILLANSPECIALMARKETS@MACMILLAN.COM.

FIRST EDITION: 2020

10 9 8 7 6 5 4

A Wealth of Pigeons

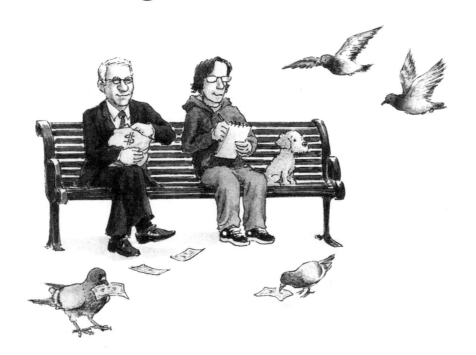

INTRODUCTION
by
Steve Martin

I'VE ALWAYS LOOKED UPON CARTOON-ING AS COMEDY'S LAST FRONTIER. I HAVE DONE STAND-UP, SKETCHES, MOVIES, MONOLOGUES, AWARDS SHOW INTRO-DUCTIONS, SOUND BITES, BLURBS, TALK SHOW APPEARANCES, AND TWEETS, BUT THE IDEA OF A ONE-PANEL IMAGE WITH OR WITHOUT A CAPTION MYSTIFIED ME. I FELT LIKE, YEAH, SOMETIMES I'M FUNNY, BUT THERE ARE THESE OTHER WEIRD FREAKS WHO ARE *ACTUALLY FUNNY.* YOU CAN UNDERSTAND THAT I WAS DEEPLY SUSPICIOUS OF THESE PEOPLE WHO ARE *ACTUALLY FUNNY.*

A PHRASE THAT HAS STUCK IN MY HEAD FOR DECADES WAS UTTERED BY JACKSON POLLOCK. IN THE ONLY FILMED DOCUMENTARY OF HIM (BY HANS NAMUTH), HE SAID HE HAD "LOST CONTACT" WITH A PAINTING HE WAS WORKING ON AND STARTED A NEW ONE. I HAD THAT FEELING ABOUT WRITING COMIC ESSAYS FOR *THE NEW YORKER.* ONE DAY, I NO LONGER UNDERSTOOD IT, HOW TO BE FUNNY IN IT, AND I STOPPED. YEARS WENT BY. YET, *THE NEW YORKER* CONTINUED TO ARRIVE WITH FUNNY ESSAYS AND THOSE DAMNABLE FUNNY CARTOONS. BUT I HAD NEVER LOST CONTACT WITH CARTOONING BECAUSE I HAD NEVER HAD CONTACT IN THE FIRST PLACE.

MY WIFE, ANNE, USED TO COMMENT ON THE OCCASIONAL DIM-WITTEDNESS OF OUR DOG, WALLY, "WELL, HE DOESN'T HAVE AN OPPOSABLE THUMB." I STARTED TO SEE THIS AS A POSSIBLE CARTOON, NOW ILLUSTRATED IN THIS BOOK.

ONE EVENING AT A COCKTAIL PARTY, I FOUND MYSELF IN THE PRESENCE OF FRANÇOISE MOULY, THE ART AND COVER EDITOR OF *THE NEW YORKER.* I MENTIONED THAT I HAD A CARTOON IDEA AND DID SHE KNOW ANYONE WHO MIGHT

DRAW IT. "I KNOW WHO YOU SHOULD WORK WITH," SHE SAID: "HARRY BLISS." "I LOVE HIM," I SAID, AND SHE PUT ME IN CONTACT WITH HARRY. HARRY BLISS TURNED OUT TO BE THE IDEAL PARTNER: WE RARELY SPEAK TO EACH OTHER, AND WE LIVE IN DIFFERENT STATES.

HARRY DREW THE CARTOON PERFECTLY. PERFECTLY SPARE AND PERFECTLY CLEAR. I WAS MOTIVATED. I WENT TO BED AFTER A FEW EMAILS WERE EXCHANGED AND FOUND THAT NIGHT WAS THE PERFECT BACKDROP FOR DREAMING UP CARTOONS. LYING IN BED IN THE WEE HOURS, EYES OPEN OR EYES CLOSED, I STARED AT A SLATE OF BLACKNESS ACROSS WHICH IMAGES, ODD WORDS, OR ODD CHARACTERS WOULD FLOAT.

THEN, HARRY BEGAN SENDING ME ORPHAN DRAWINGS FOR CAPTIONS, AND WE DISCOVERED WE HAD TWO WAYS TO WORK: FORWARDS AND BACKWARDS. FORWARDS WAS ME CONCEIVING OF SEVERAL CARTOON IMAGES AND CAPTIONS, AND HARRY WOULD SELECT HIS FAVORITES; BACKWARDS WAS HARRY SENDING ME SKETCHED OR FULLY DRAWN CARTOONS FOR DIALOGUE OR BANNERS. I LOVED THE PROCESS OF THE "CAPTION CONTEST" FOR PROFESSIONALS. (THOUGH I STILL MARVEL AT THE HUMOR OF THE SO-CALLED NON-PRO, FROM TWITTER RESPONSES TO CAPTION WRITING.) SOMETIMES I WOULD GET SOMETHING RIGHT AWAY, SOMETIMES IT WOULD TAKE FOUR OR FIVE GOES, SOMETIMES, NOTHING. AND THERE'S ALWAYS THE LITTLE MIRACLE OF COMEDY, IN CARTOONING, MOVIES, AND SKETCHES, WHERE, AFTER WEEKS OF AGONIZING, THE PERFECT JOKE OCCURS TWO SECONDS BEFORE DEADLINE.

AFTER ONE YEAR OF WORK, HARRY AND I CAME UP WITH AROUND ONE HUNDRED FIFTY CARTOONS. I'VE COME TO APPRECIATE HARRY'S REPERTOIRE MORE AND MORE THROUGHOUT THIS PROCESS — "OH, YOU NEED SOMETHING TO LOOK LIKE REMBRANDT? SURE." — AND OUR WORK EVOLVED FROM DOGS AND CATS TO OUTER SPACE AND ART MUSEUMS.

AND FINALLY, AFTER TWEETING A SELECTION OF CARTOONS AND READING THE RESPONSES, I'VE COME TO UNDERSTAND THAT NO MATTER HOW OBVIOUS A CARTOON IS, NO MATTER HOW SIMPLE IT IS, THERE'S ALWAYS ONE RELIABLY PRESENT COMMENT WHICH I HAVE GROWN TO EMBRACE: "I DON'T GET IT."

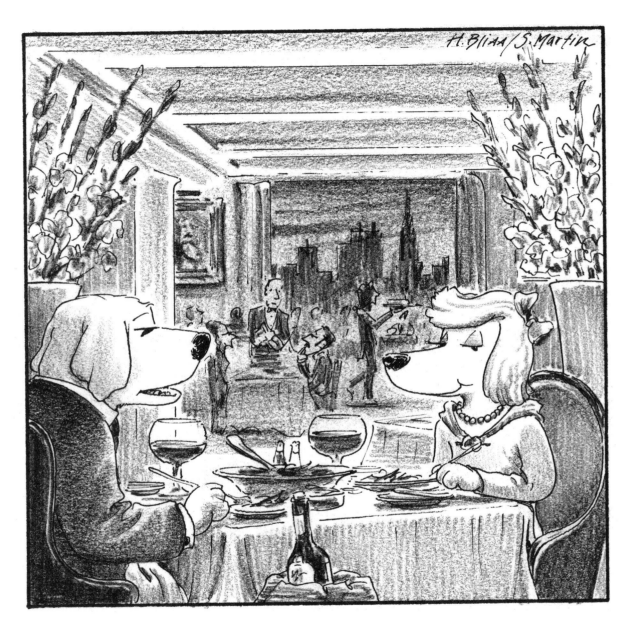

"THEN, WHEN I GOT A LITTLE MONEY, I SAID,
I'M NEVER EATING OFF THE GROUND AGAIN."

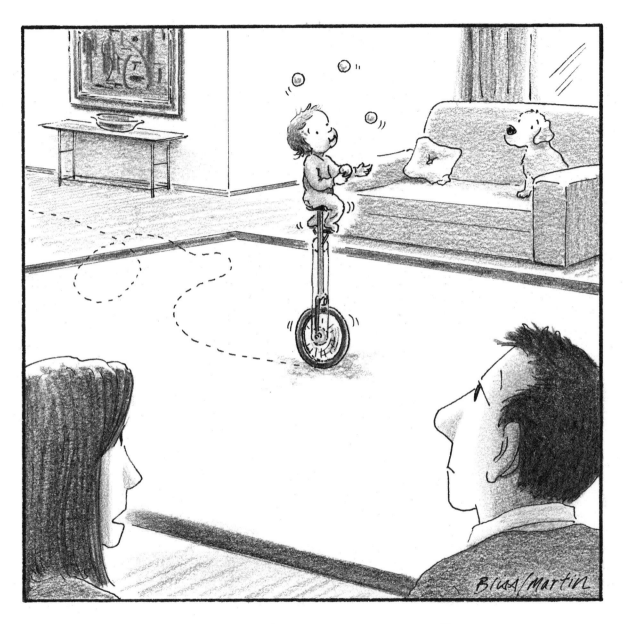

"ENCOURAGE OR DISCOURAGE?"

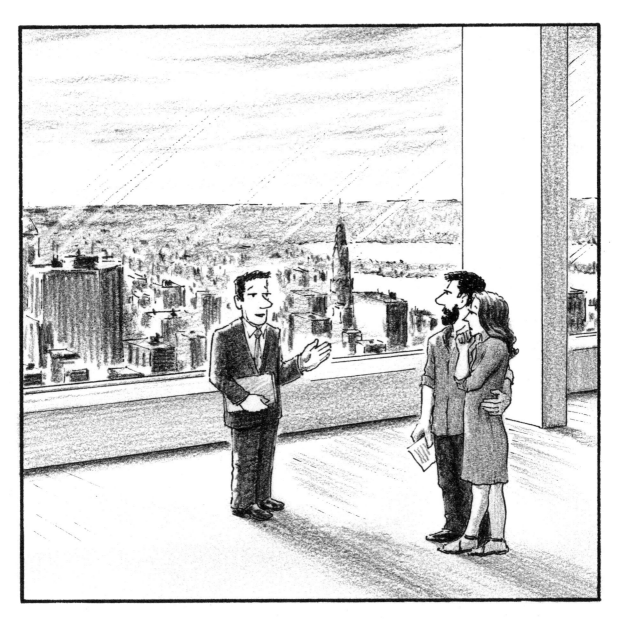

"IT'S A HUNDRED AND NINETY–FIVE MILLION. NOW, I KNOW WHAT YOU'RE THINKING. 'OKAY, WHAT'S THE CATCH?'"

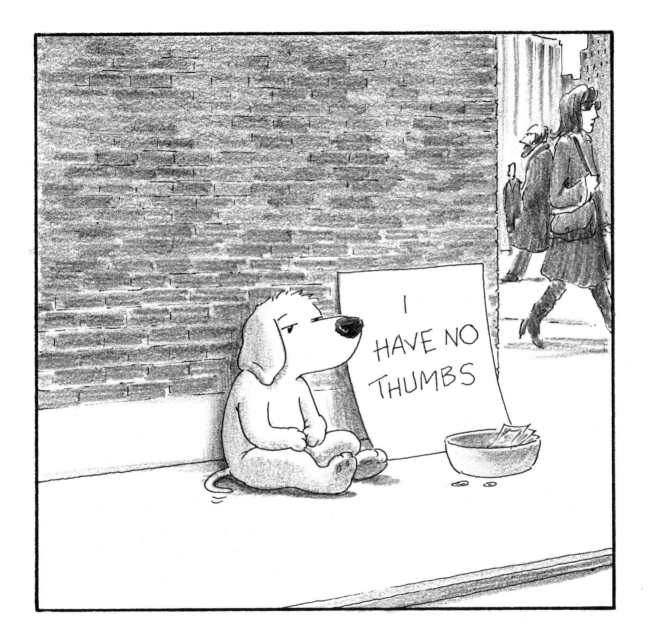

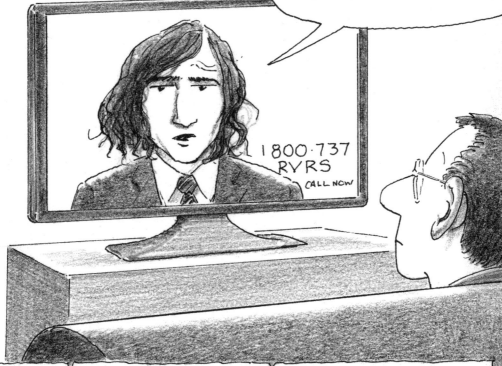

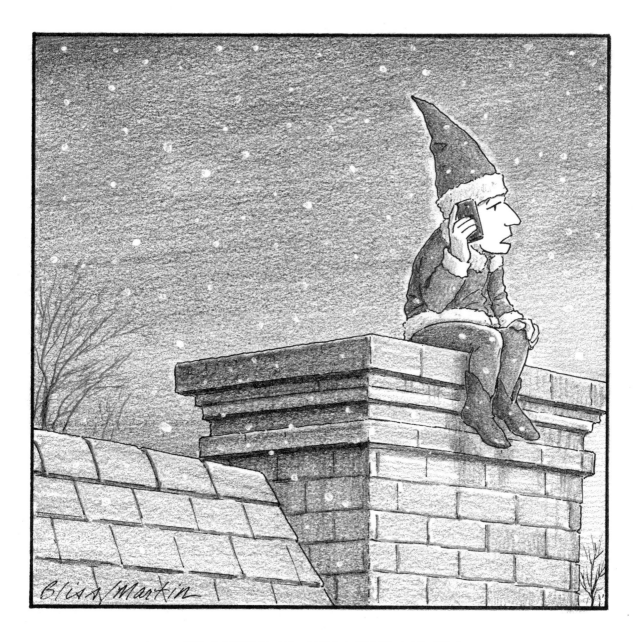

"I'M HERE. FLASH YOUR NOSE."

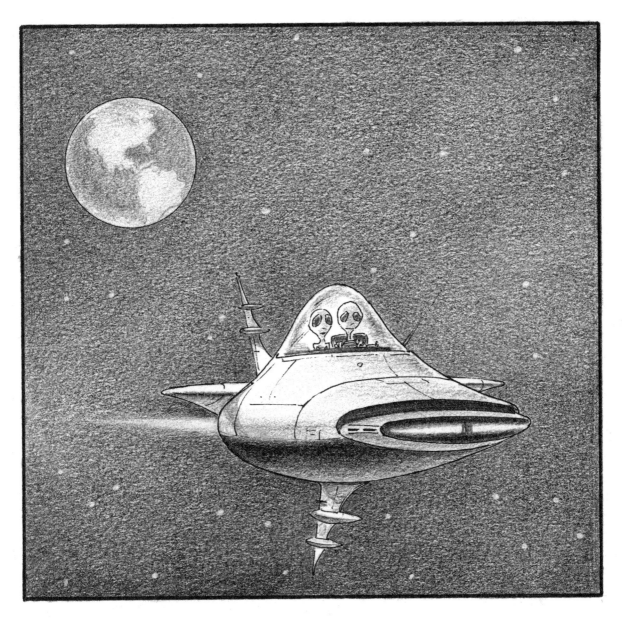

"I LIKED INSEMINATING THEIR WATER SUPPLY,
BUT OTHER THAN THAT I WAS BORED."

"THEY MEET."

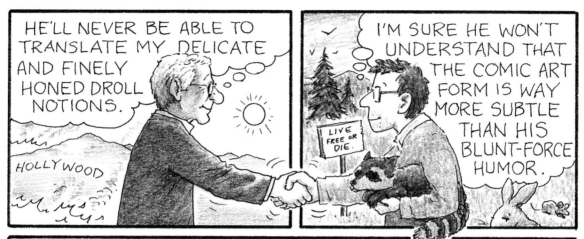

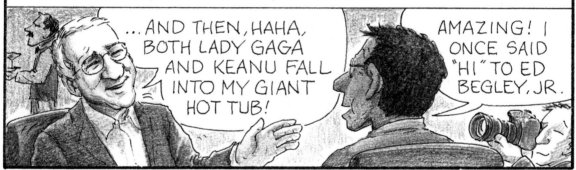

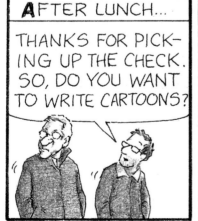

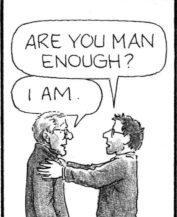

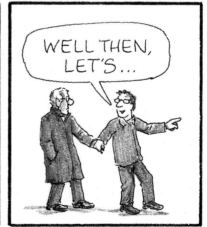

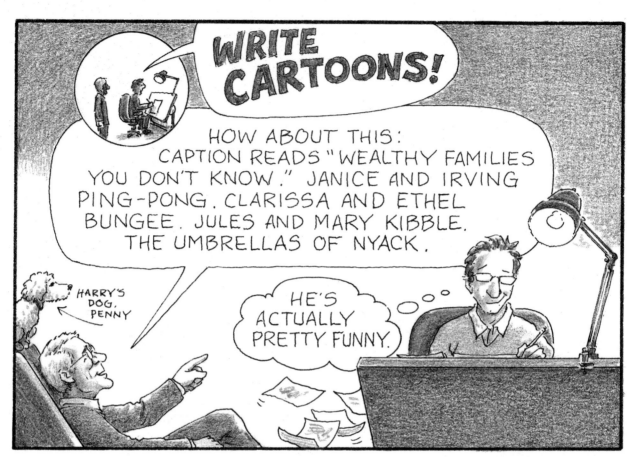

WRITE CARTOONS!

HOW ABOUT THIS:
CAPTION READS "WEALTHY FAMILIES YOU DON'T KNOW." JANICE AND IRVING PING-PONG. CLARISSA AND ETHEL BUNGEE. JULES AND MARY KIBBLE. THE UMBRELLAS OF NYACK.

HARRY'S DOG, PENNY

HE'S ACTUALLY PRETTY FUNNY.

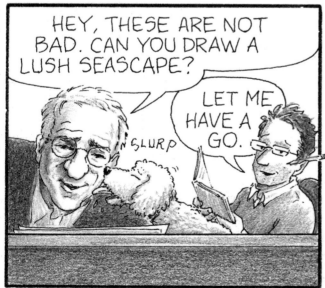

HEY, THESE ARE NOT BAD. CAN YOU DRAW A LUSH SEASCAPE?

SLURP

LET ME HAVE A GO.

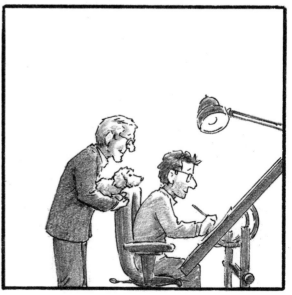

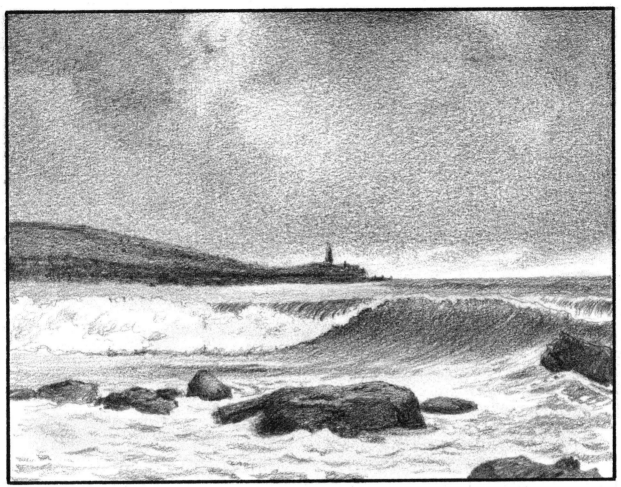

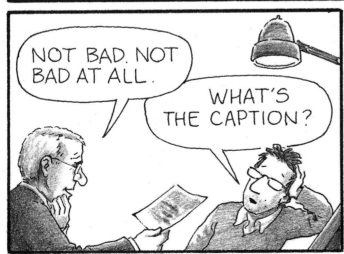

NOT BAD. NOT BAD AT ALL.

WHAT'S THE CAPTION?

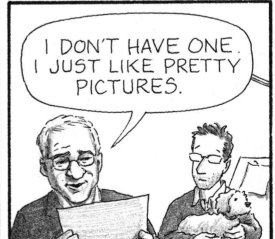

I DON'T HAVE ONE. I JUST LIKE PRETTY PICTURES.

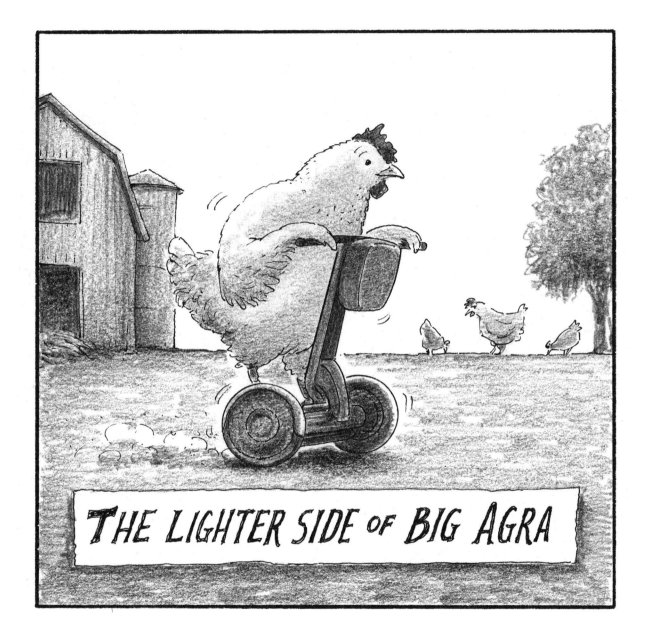

THE LIGHTER SIDE OF BIG AGRA

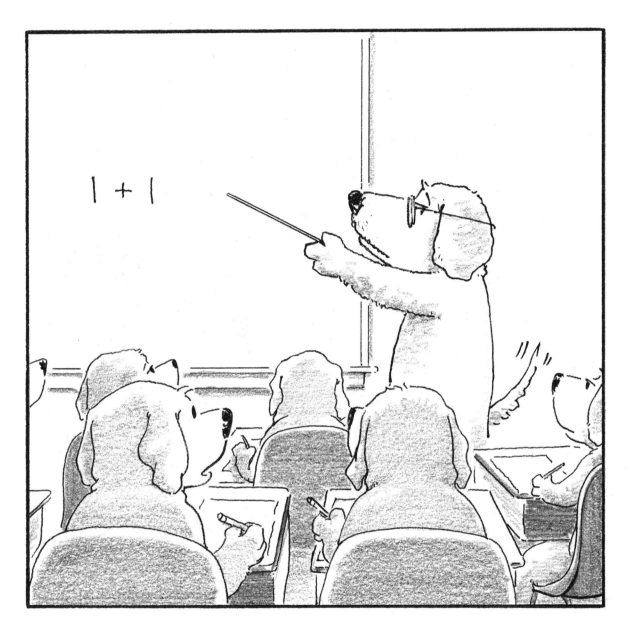

"SOMETIMES, I FEEL SO STUPID."

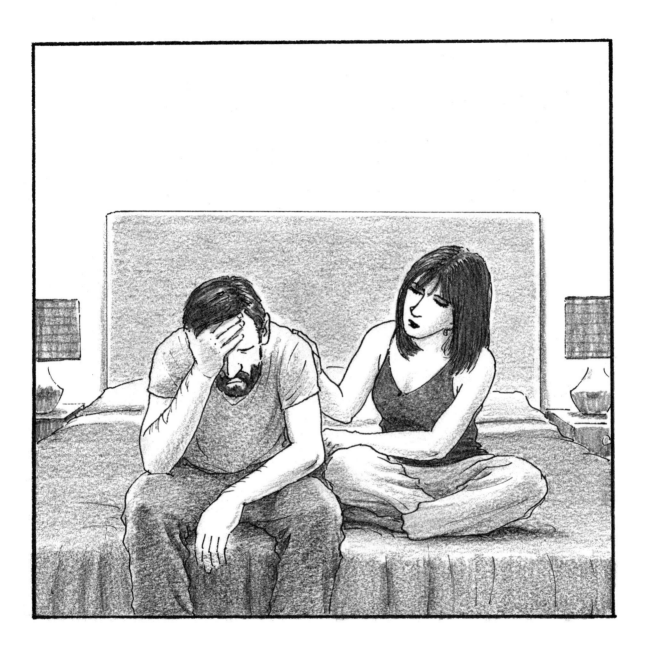

"LOOK, ALL WE DID WAS SLEEP TOGETHER.
I SAVED WATCHING *GAME OF THRONES* FOR US."

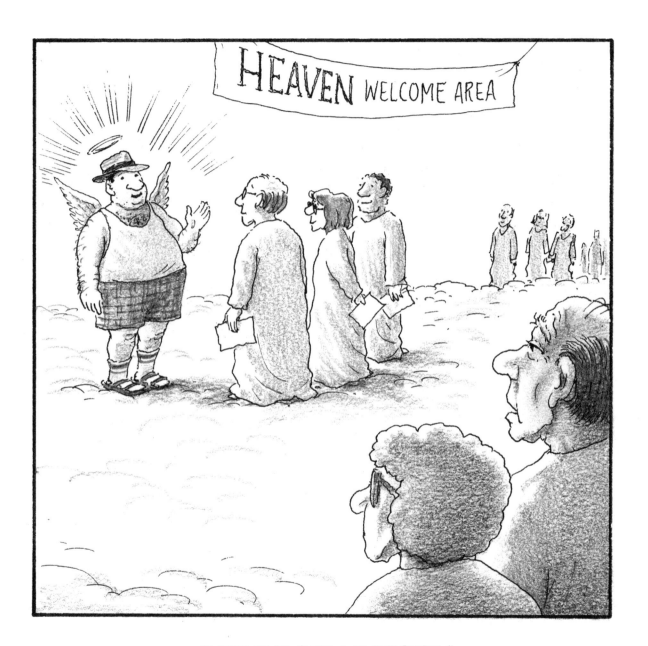

"NOT THE GOD I EXPECTED."

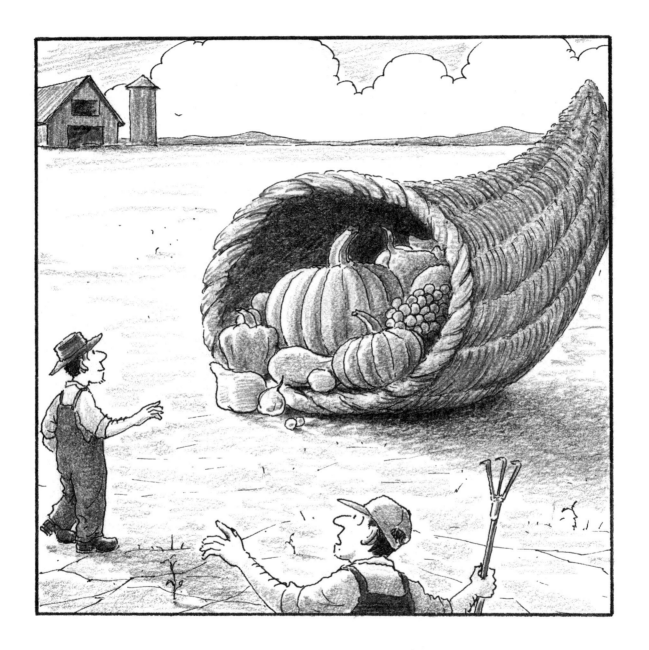

"CLEM, IT'S A TRAP!"

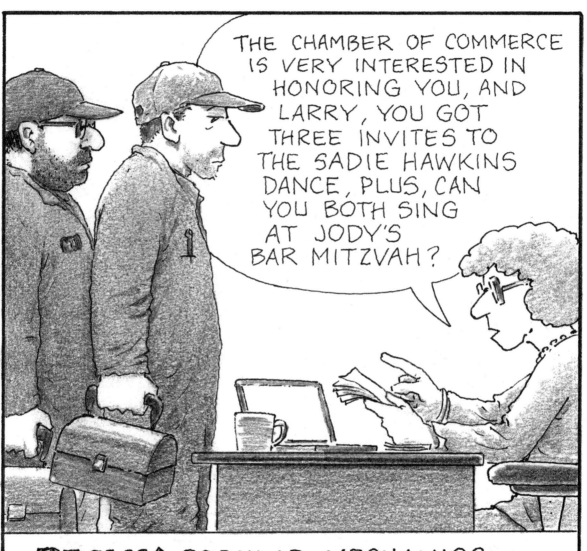

REALLY POPULAR MECHANICS

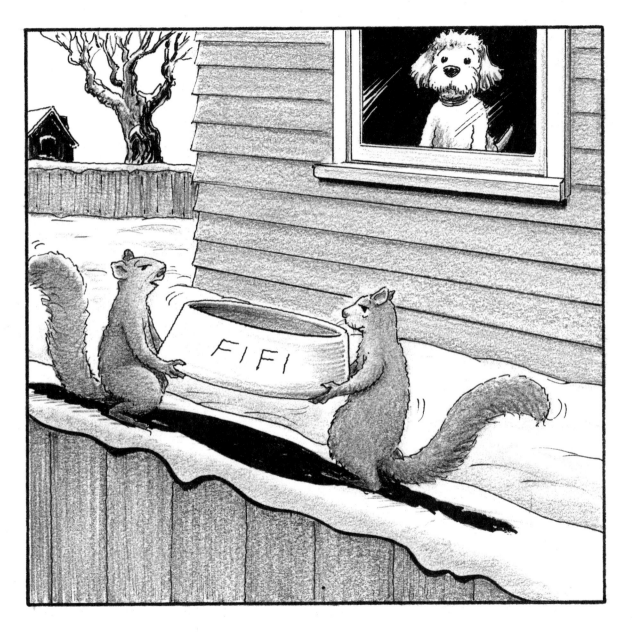

"ONCE WE FILE OFF THE NAME,
IT WILL BE UNTRACEABLE."

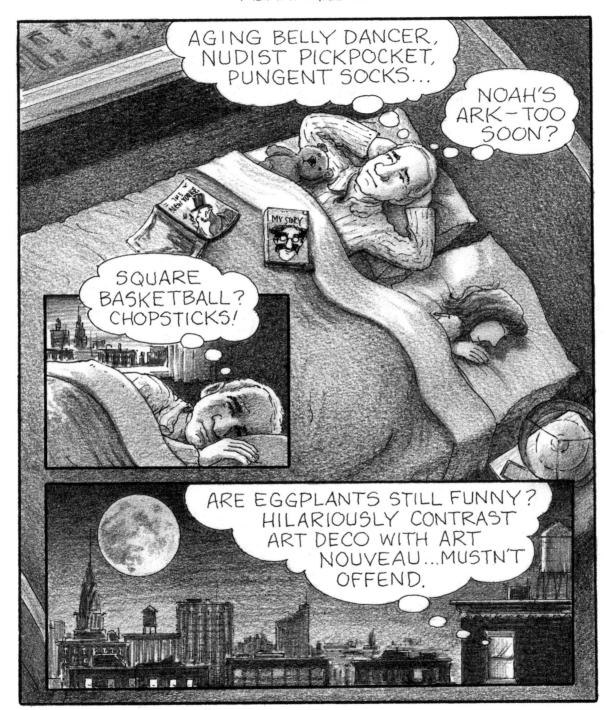

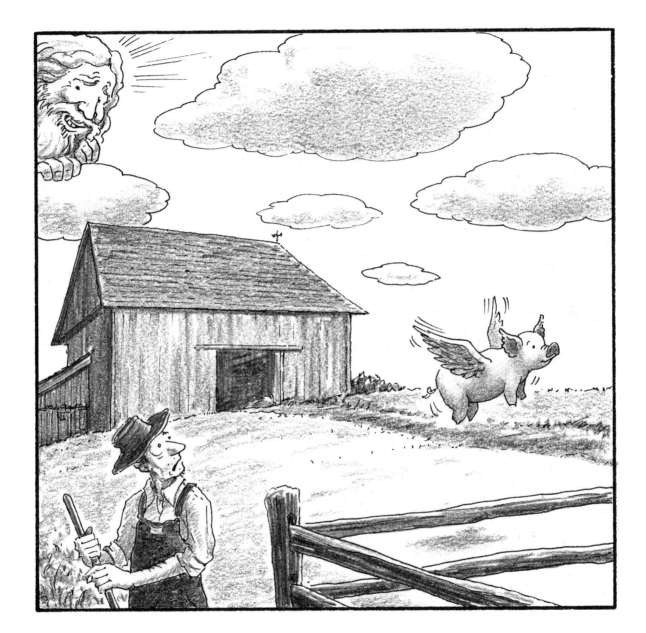

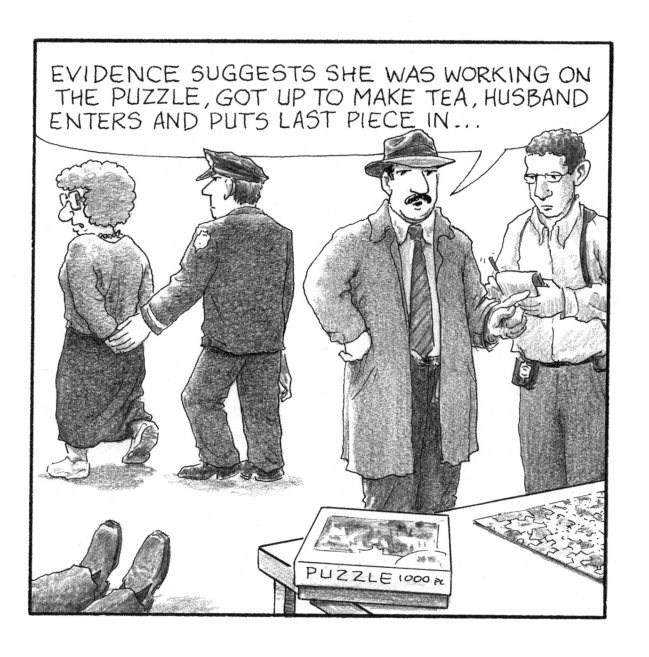

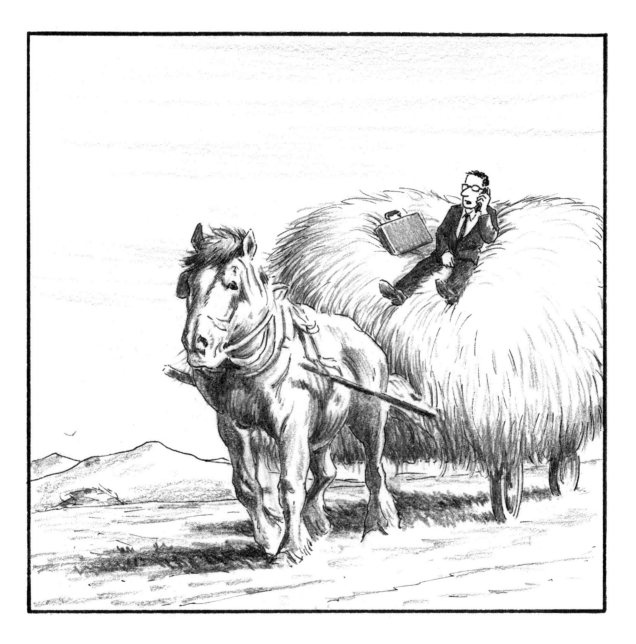

"MISS ARDEN, GO INTO MY DROPBOX, OPEN A FILE CALLED 'BUCKET LIST,' AND CROSS OFF 'HAYRIDE.'"

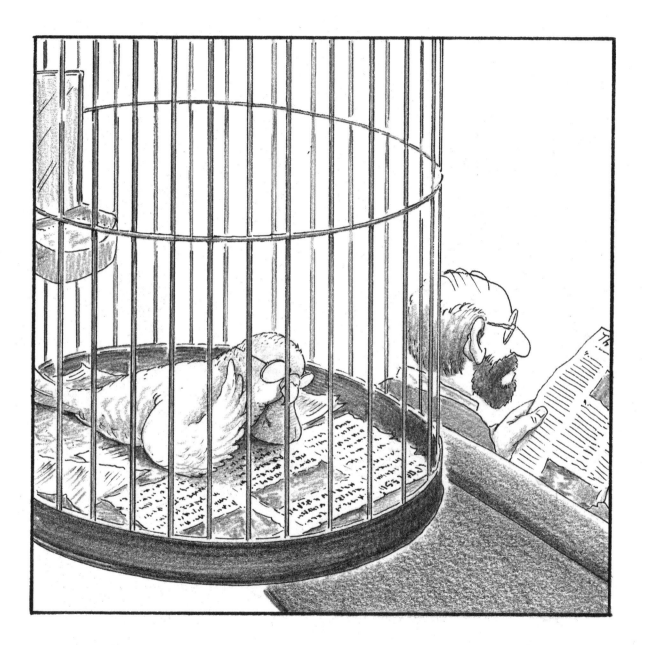

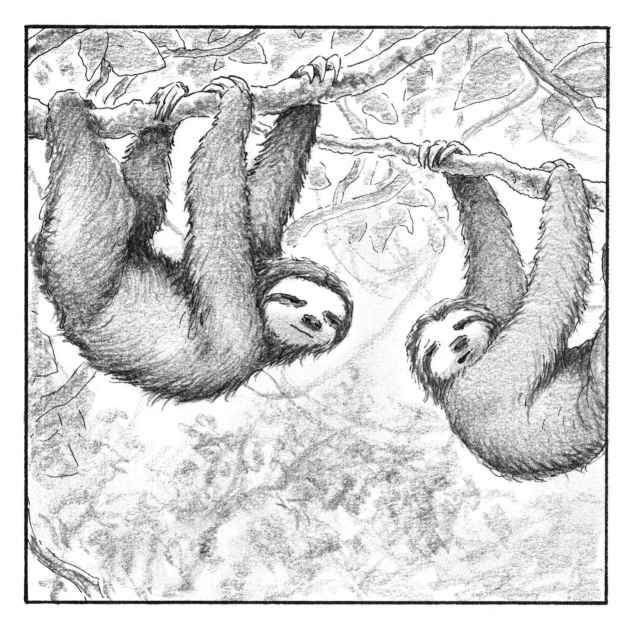

"I WISH I HAD YOUR ENERGY."

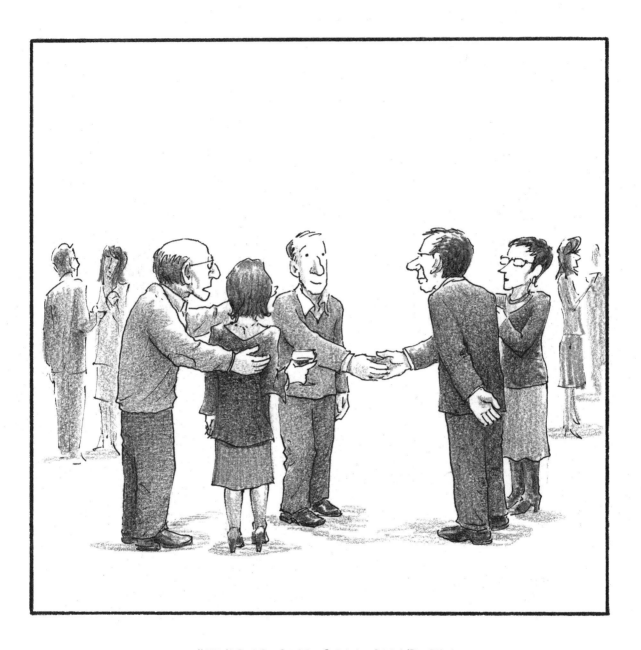

"THIS IS OUR SON, CHARLEY.
HE'S A SOUVENIR FROM WOODSTOCK."

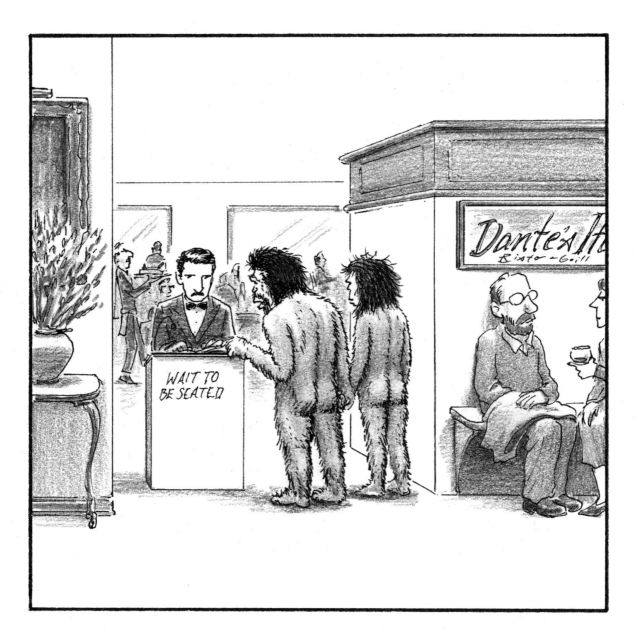

". . . MAYBE IT'S UNDER 'APEMAN.'"

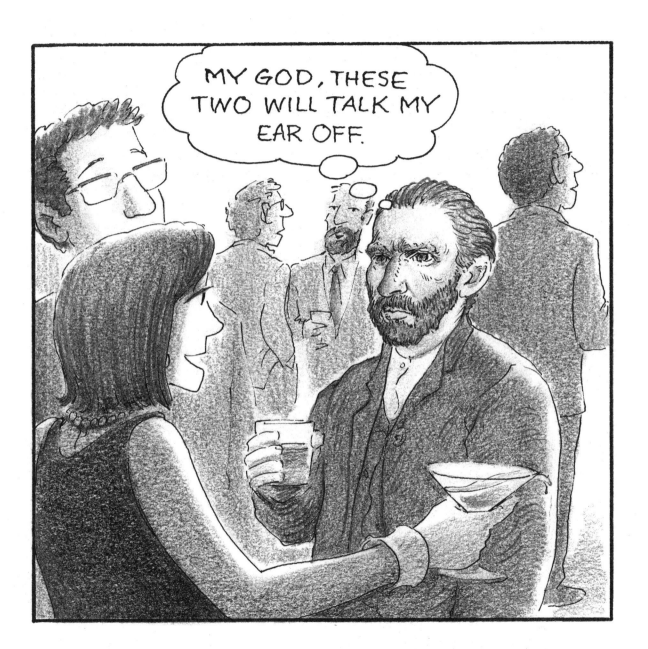

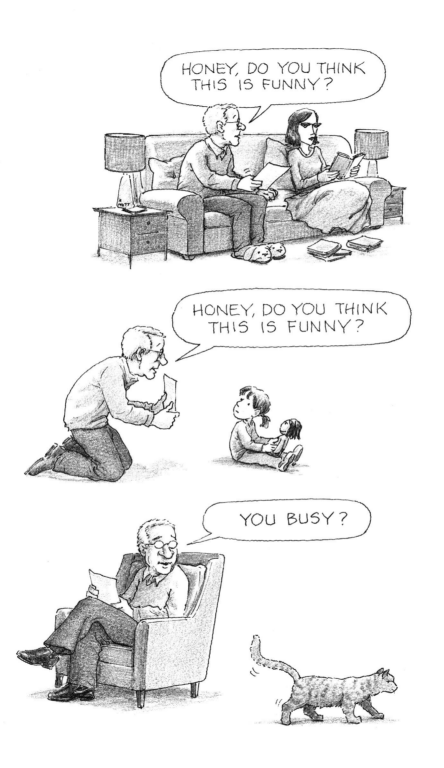

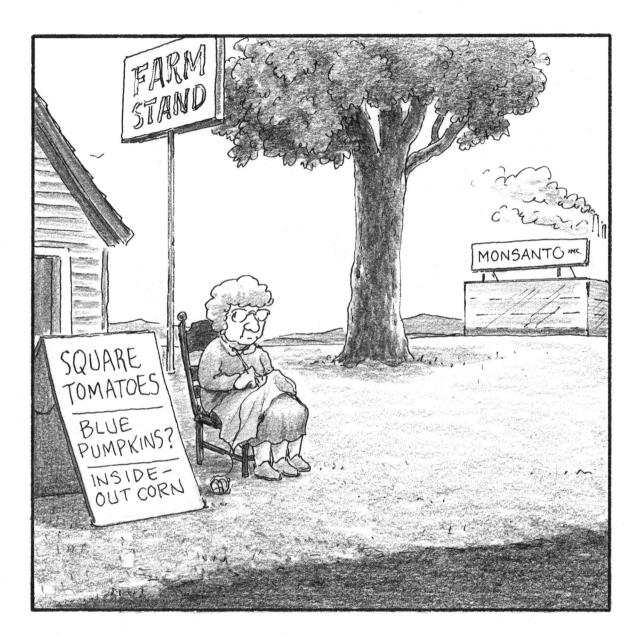

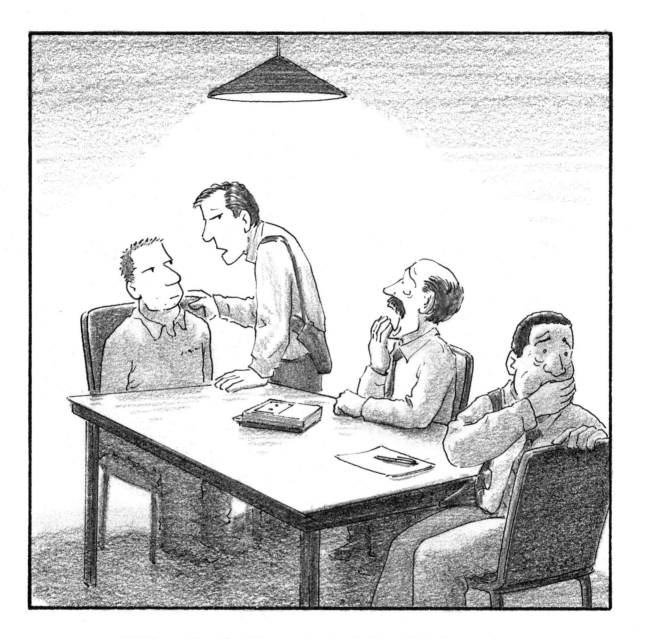

"TELL US AGAIN — A LITTLE LESS GRAPHIC."

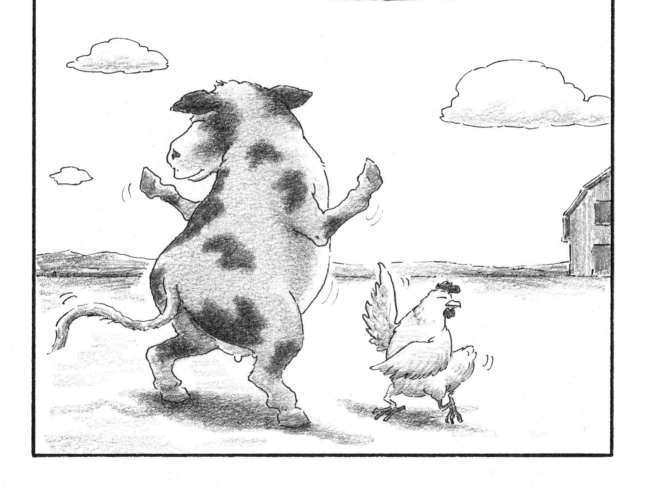

"I SEE A HORSE, A PUPPY, AND THAT ONE LOOKS LIKE A RAUSCHENBERG INSTALLATION."

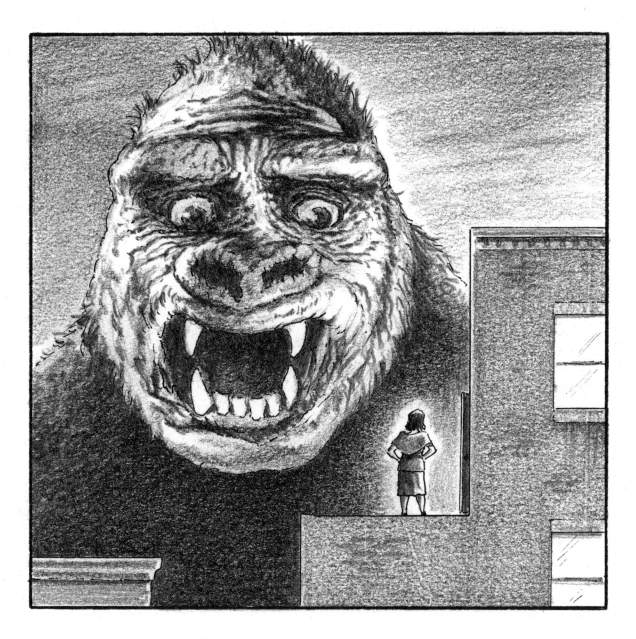

"AFTER THE DRUGSTORE, I NEED YOU TO FIND
FRESH PARMESAN."

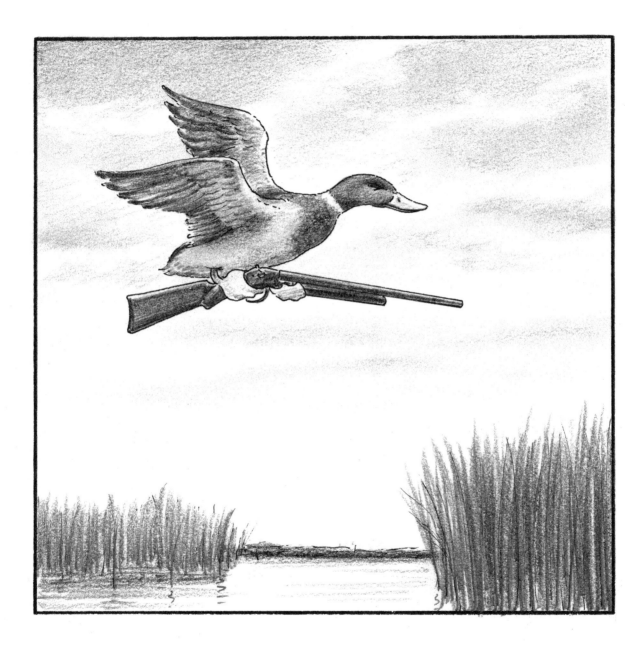

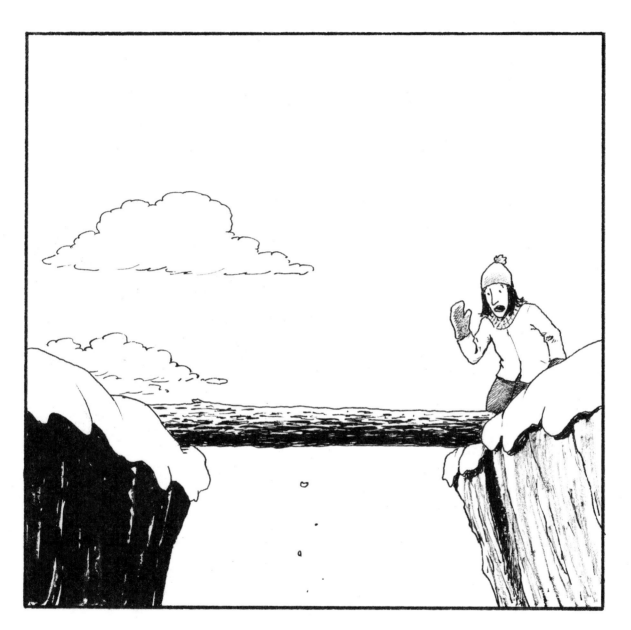

"HANG ON, PHIL! BUT I GUESS YOU
ALREADY KNEW THAT."

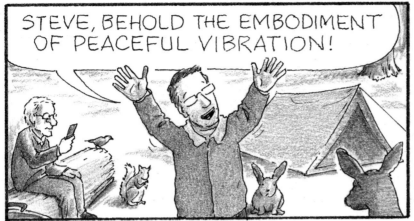
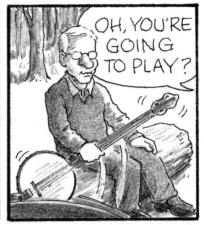
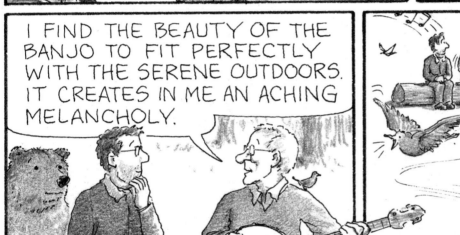
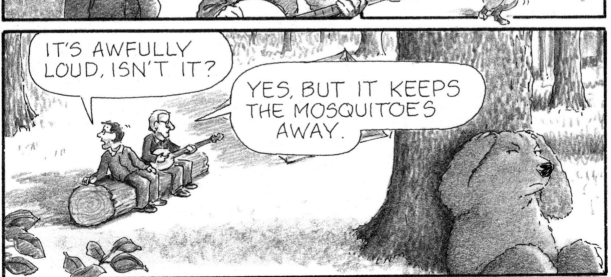

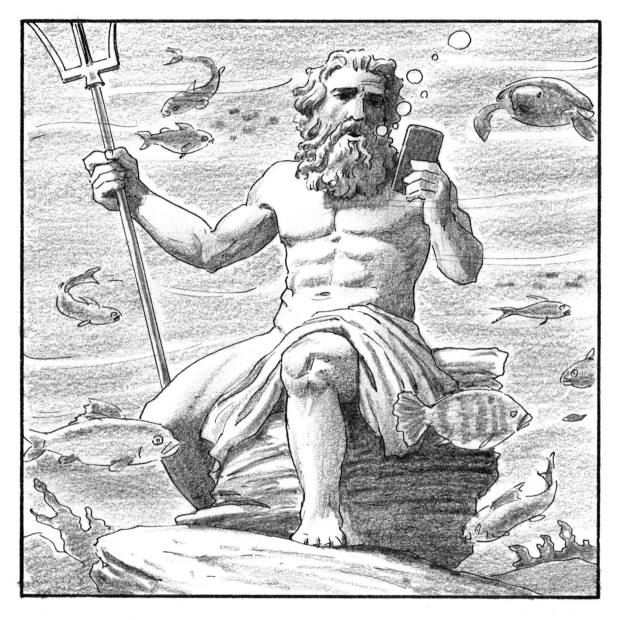

"HOLD ON, THE INTERNET IS REALLY SLOW HERE."

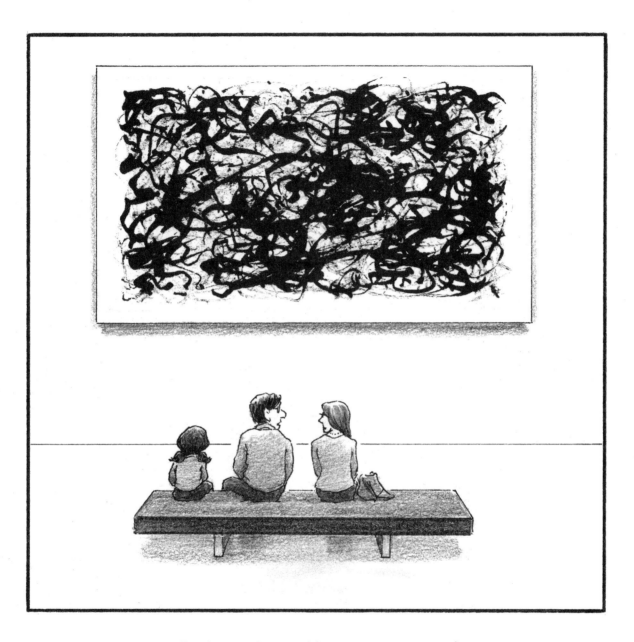

"SHE SAID IT HAS A BLISTERING
FERVENCY THAT REMINDS HER OF A SLIDE."

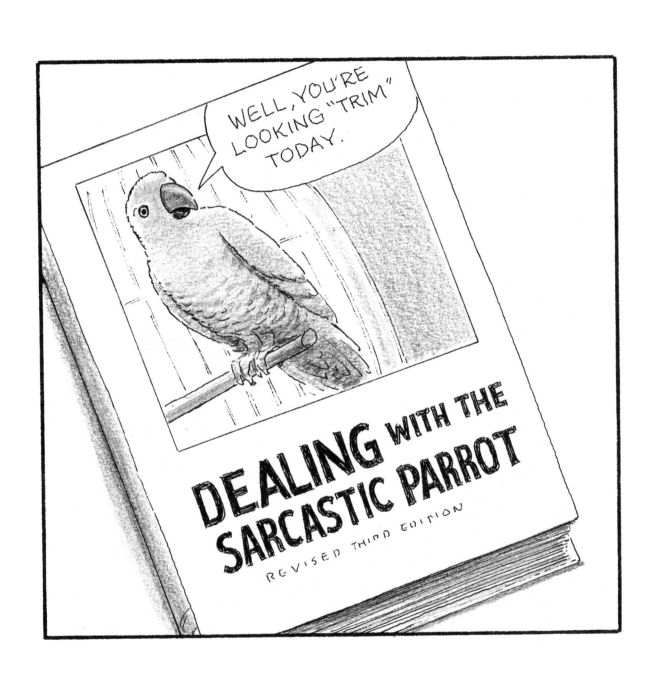

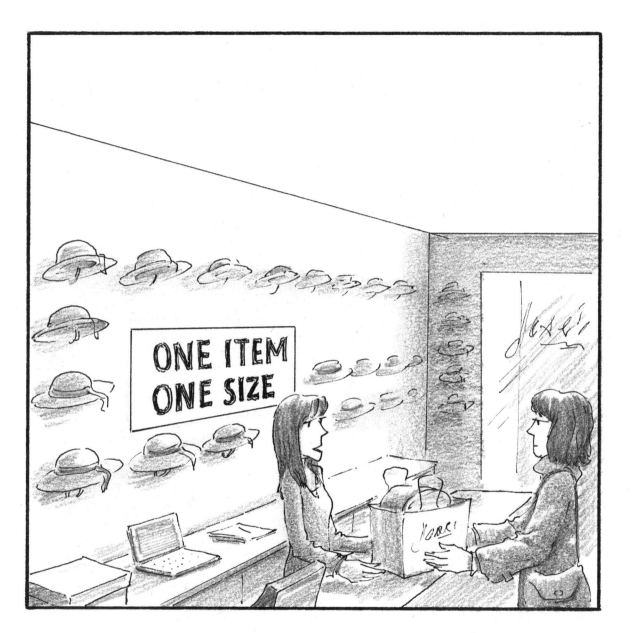

"FOR MONTHS WE'LL SELL NOTHING.
THEN SUDDENLY, WE'LL SELL TWO."

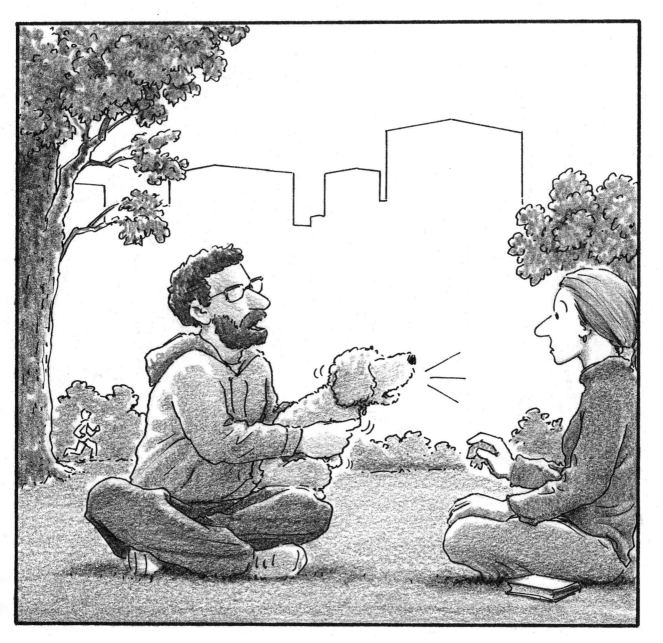

"IF YOU HEAR HIM WITH AN ORCHESTRA,
IT'S A WHOLE OTHER THING."

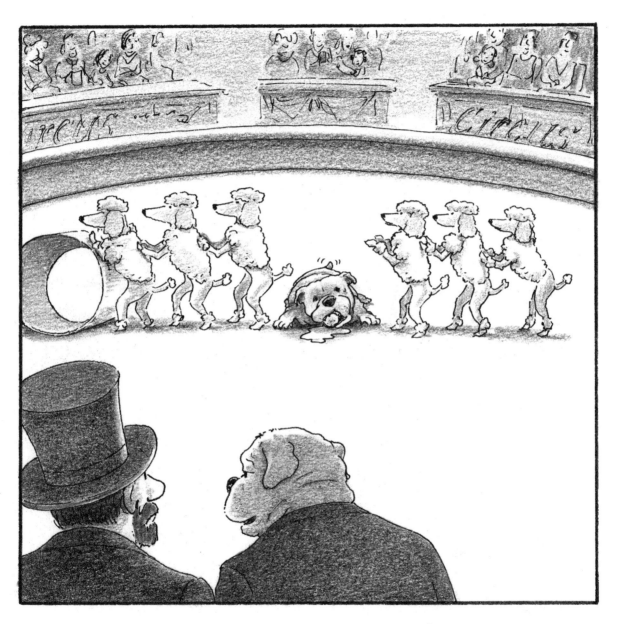

"ISN'T MY NEPHEW GREAT?"

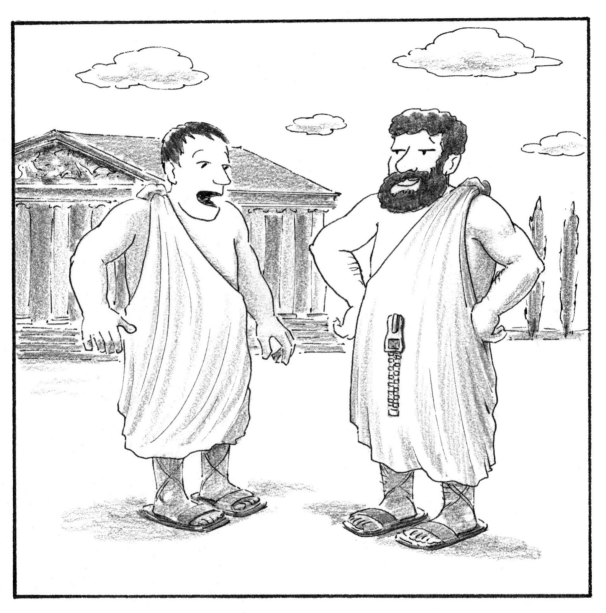

"ARCHIMEDES, YOU'VE DONE IT AGAIN."

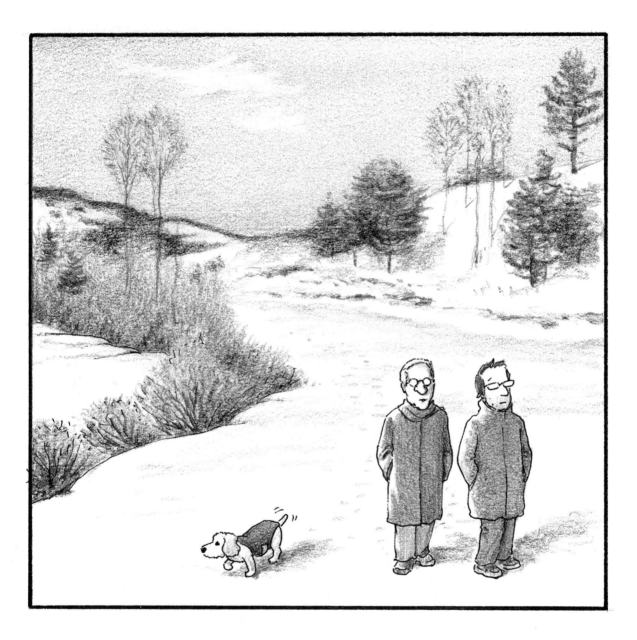

"I FEEL SORRY FOR PEOPLE WHO CAN'T
ENJOY THIS MOMENT. LIKE ME."

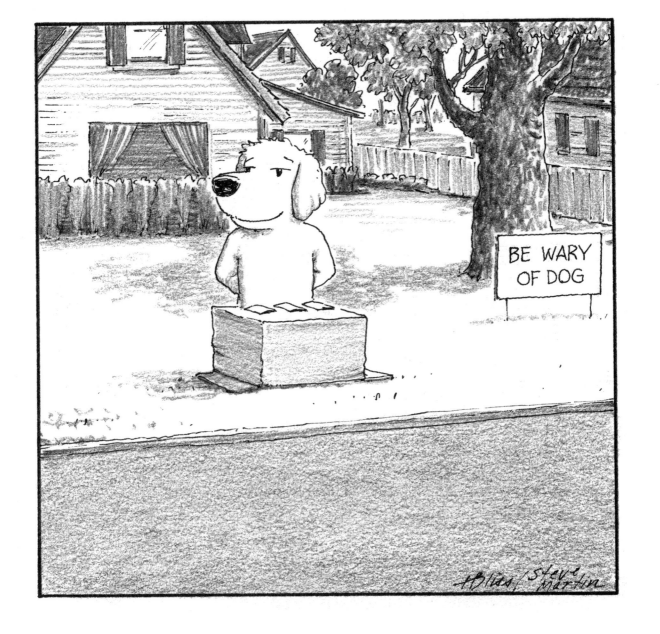

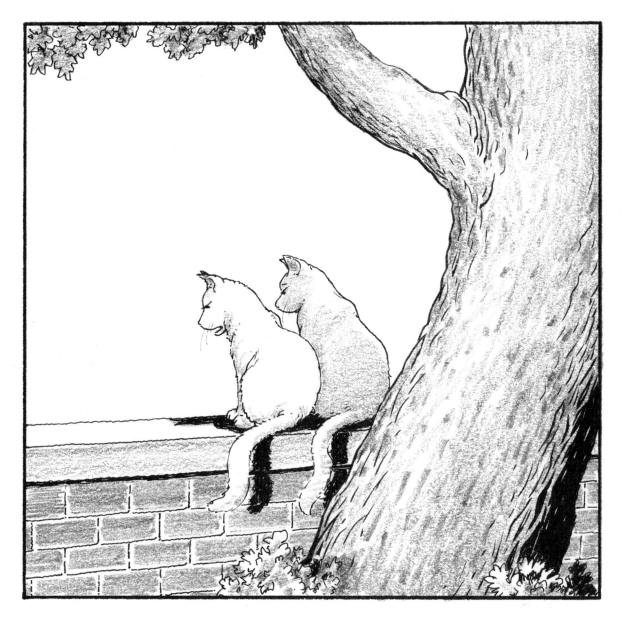

"I LOVE IT WHEN DOGS WORK ON THEIR STUPID."

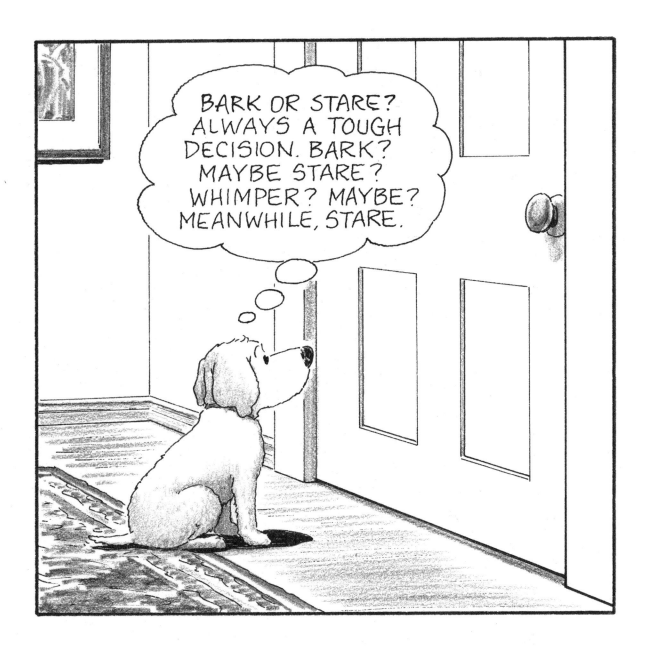

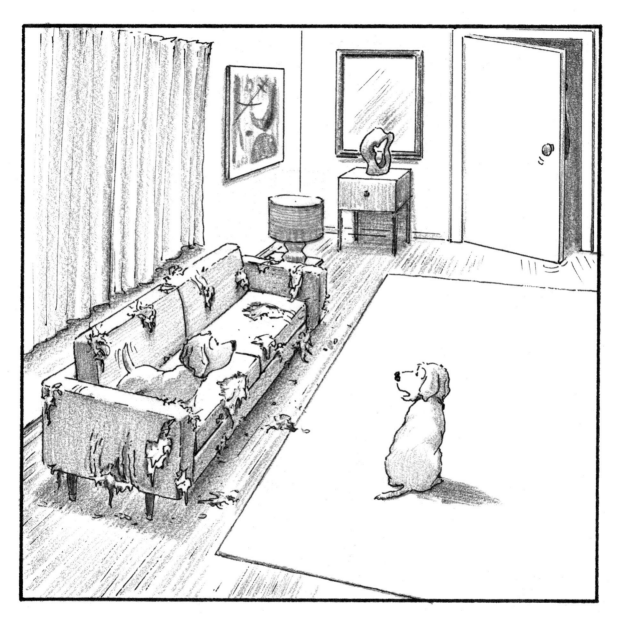

"QUICK, ACT CASUAL."

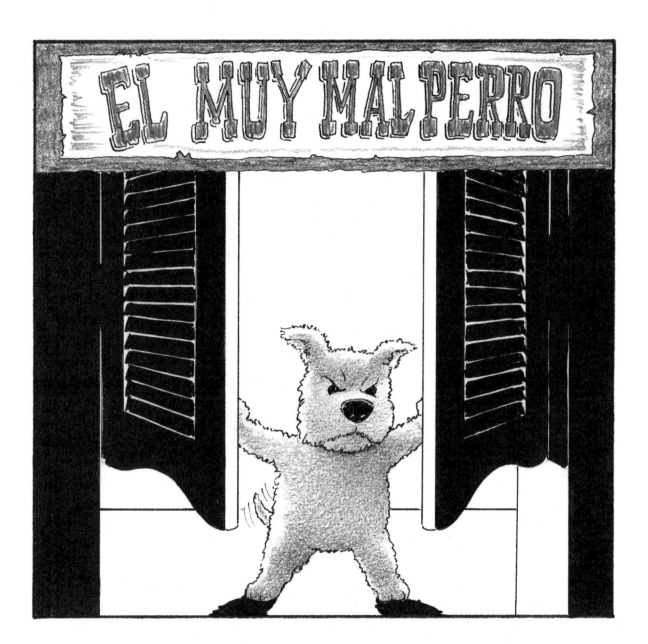

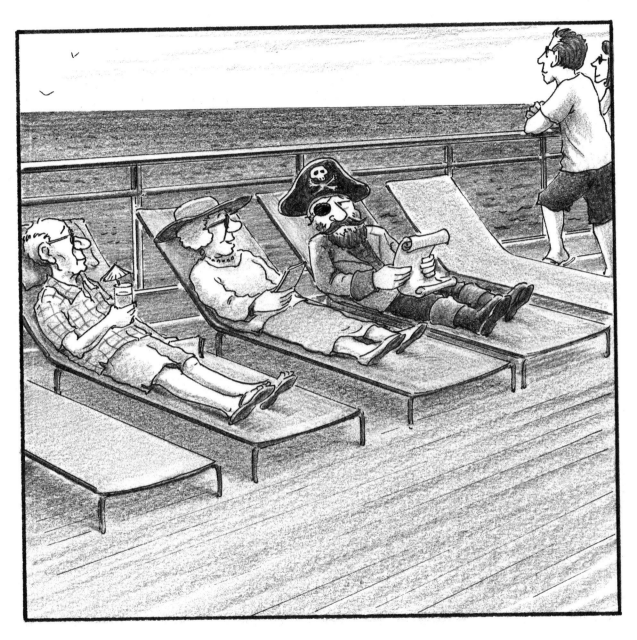

"SO, WHAT DID YOU USED TO DO?"

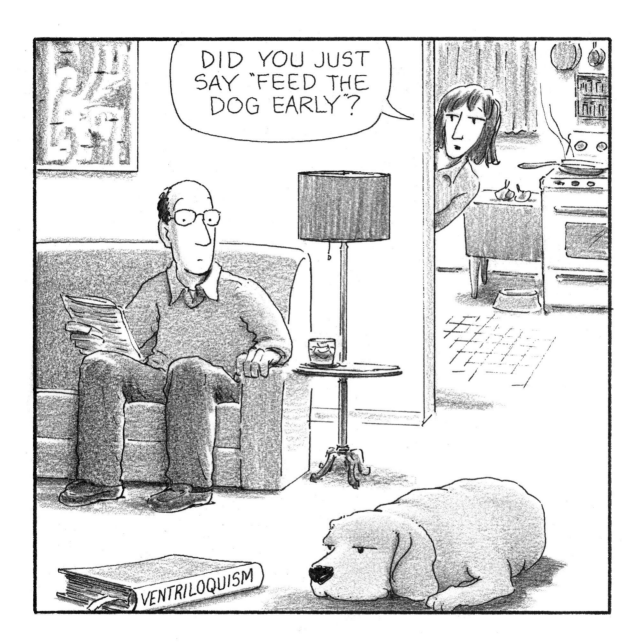

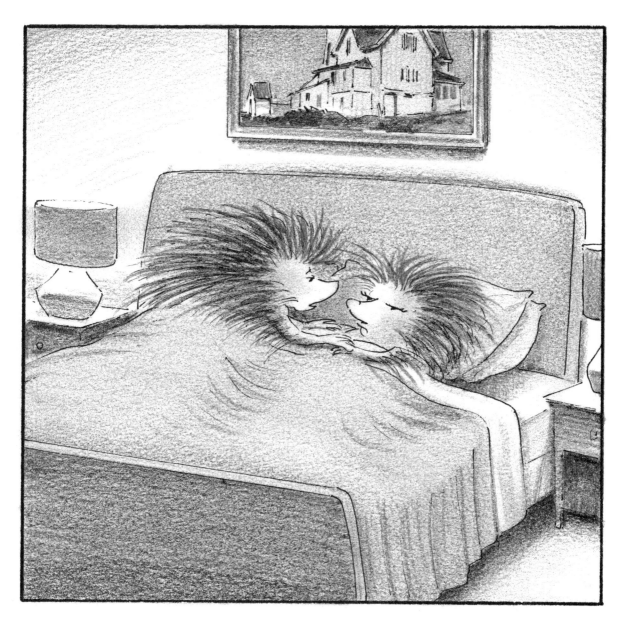

"SO, HOW *DO* WE DO THIS?"

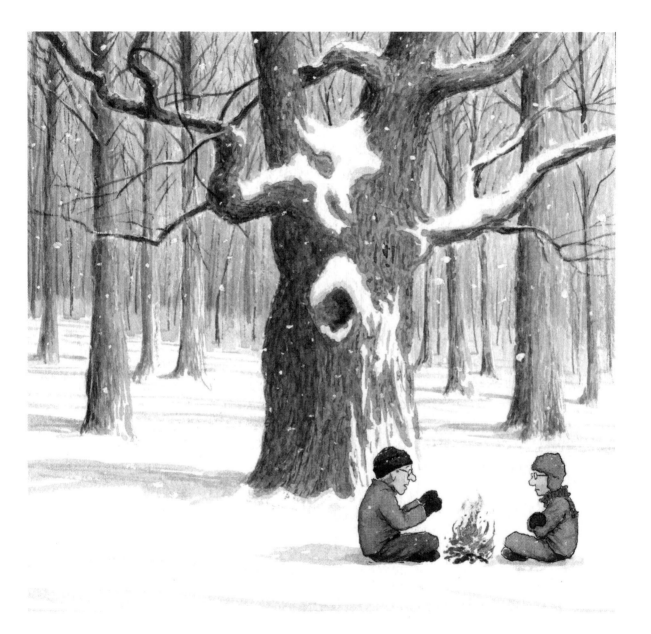

"WOW, WHO INVENTED THIS?"

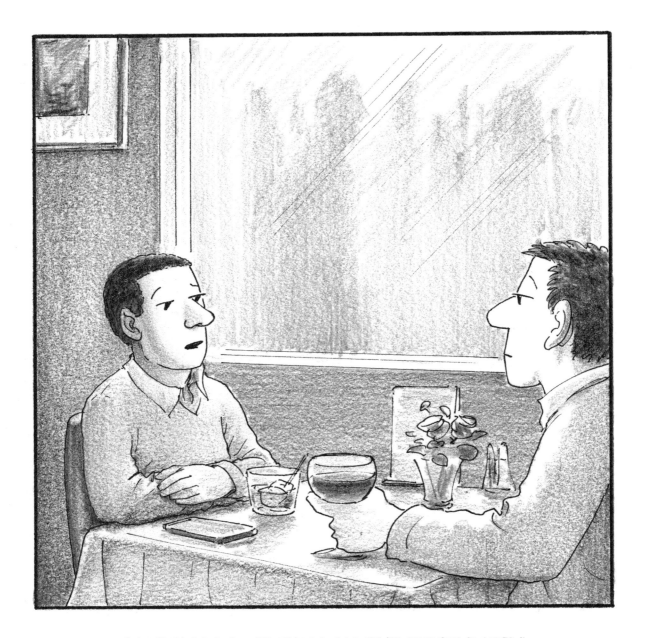

"SORRY, I DON'T TALK ON THE FIRST DATE."

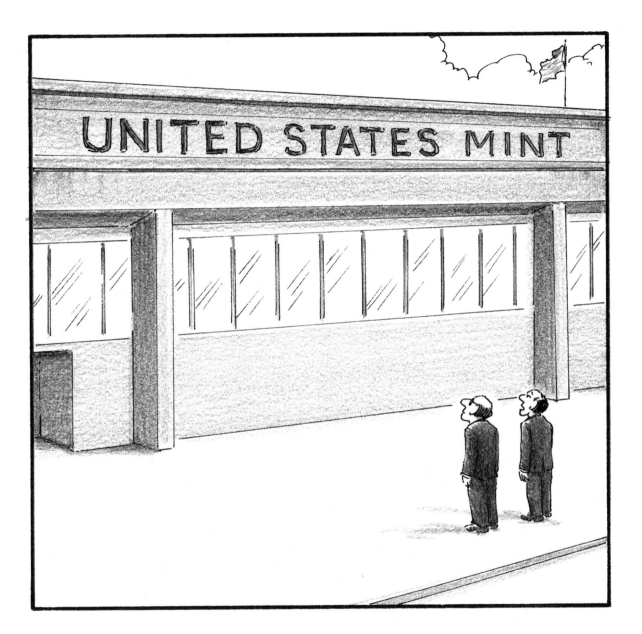

"NOW, THE QUESTION IS, HOW CAN WE MONETIZE IT?"

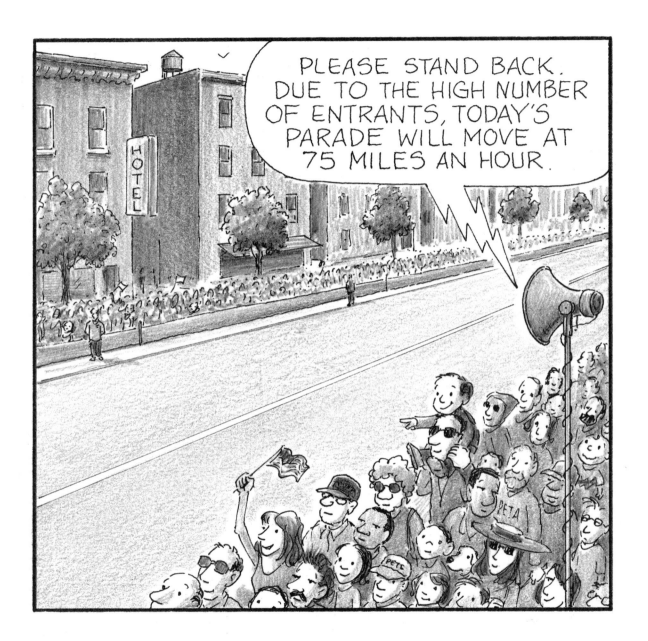

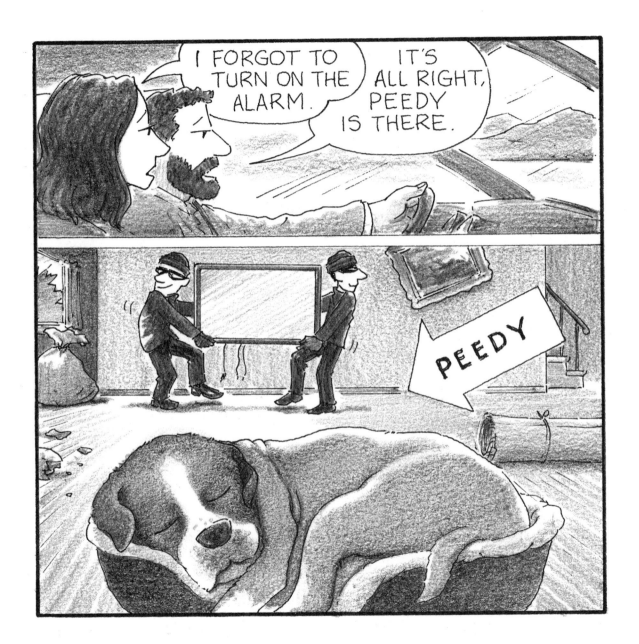

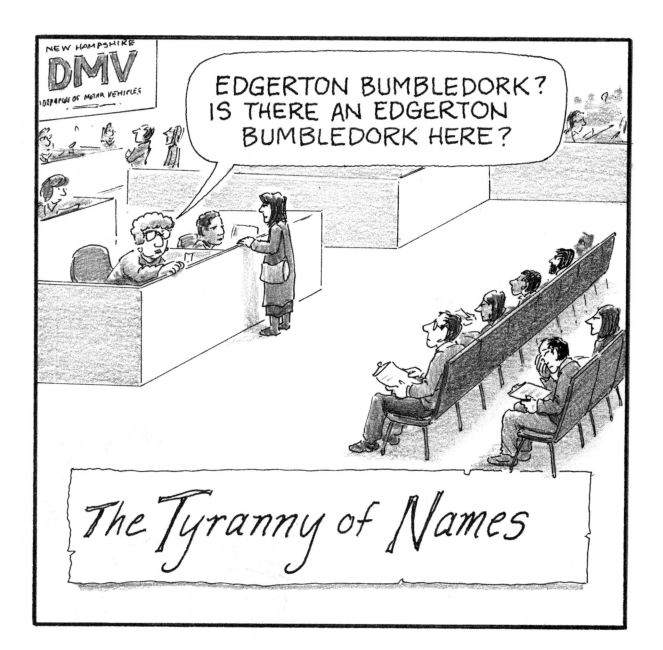

The Tyranny of Names

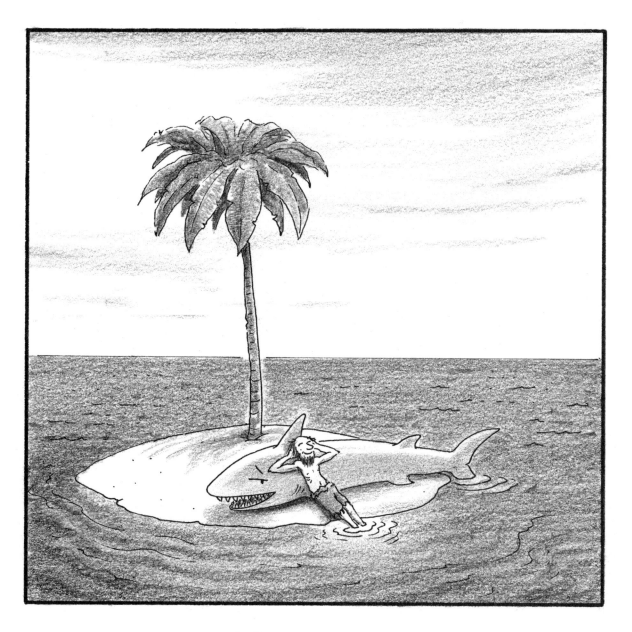

"IT'S BEEN A GREAT WEEKEND, JOHN, BUT
NOW I'M GETTING HUNGRY."

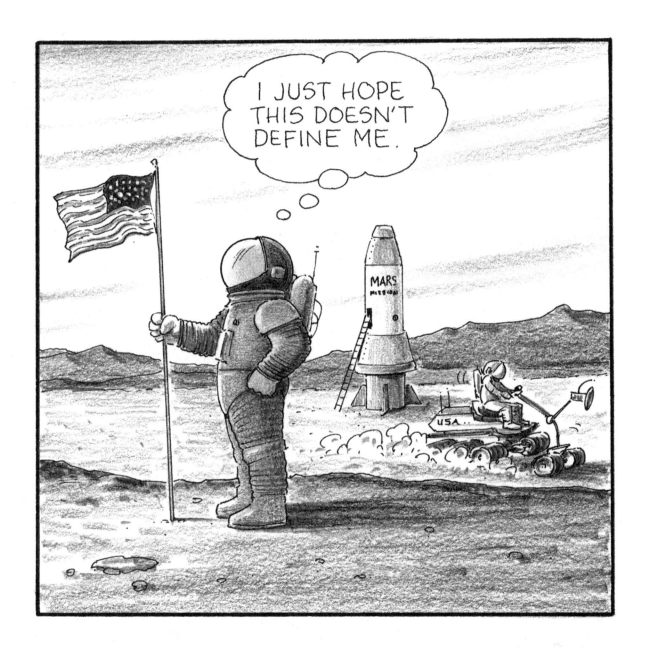

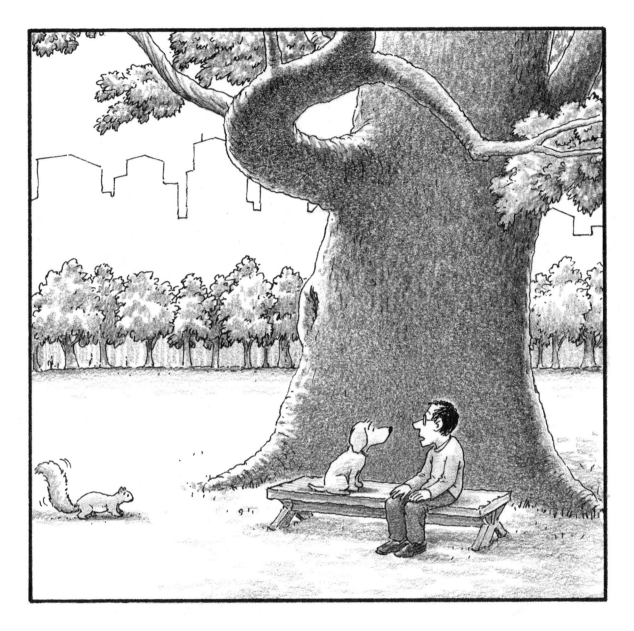

"OKAY, SHE'S BACK. JUST START SLOWLY,
AND REMEMBER TO ASK HER ABOUT HERSELF."

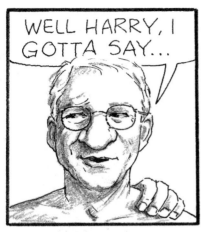

WELL HARRY, I GOTTA SAY...

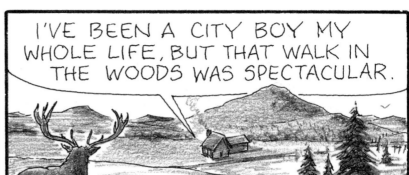

I'VE BEEN A CITY BOY MY WHOLE LIFE, BUT THAT WALK IN THE WOODS WAS SPECTACULAR.

I SAW A DEER, BEAR SCAT, A SQUIRREL, SOME KIND OF BIRD...

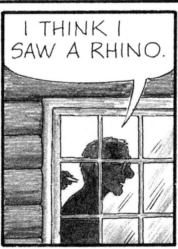

I THINK I SAW A RHINO.

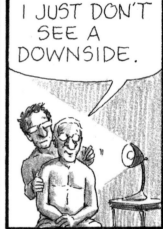

I JUST DON'T SEE A DOWNSIDE.

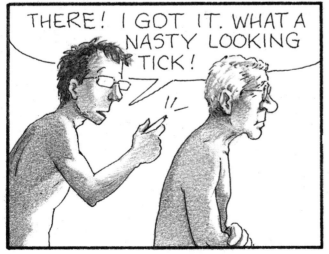

THERE! I GOT IT. WHAT A NASTY LOOKING TICK!

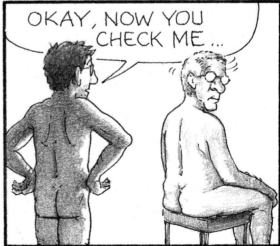

OKAY, NOW YOU CHECK ME...

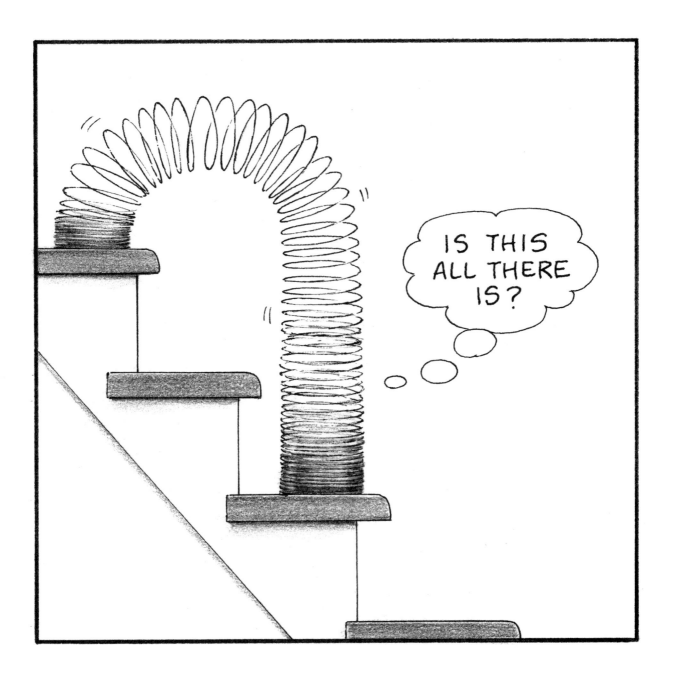

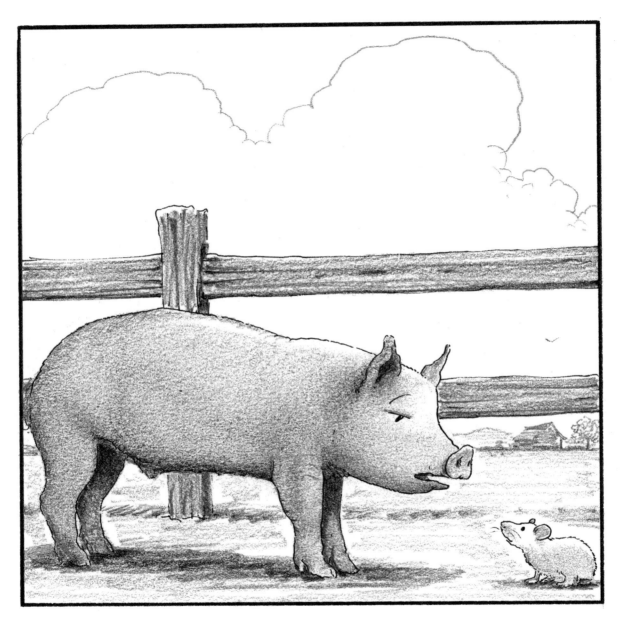

"WE'RE GOING TO HAVE TO BE VERY DISCREET.
WE DON'T TRAVEL TOGETHER, AND WE DON'T
DINE TOGETHER . . ."

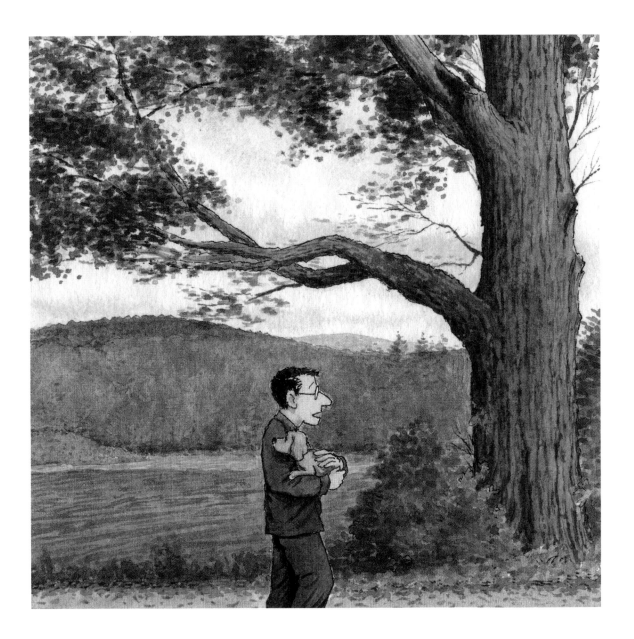

"WHAT SAY WE GO BACK, CLEAN UP THE
STAINS, AND MAKE A SINCERE APOLOGY?"

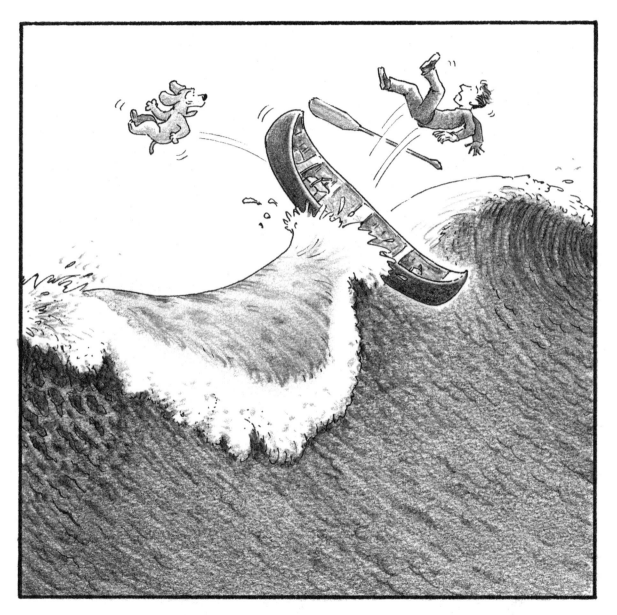

"THE LUNCH, GRAB THE LUNCH!"

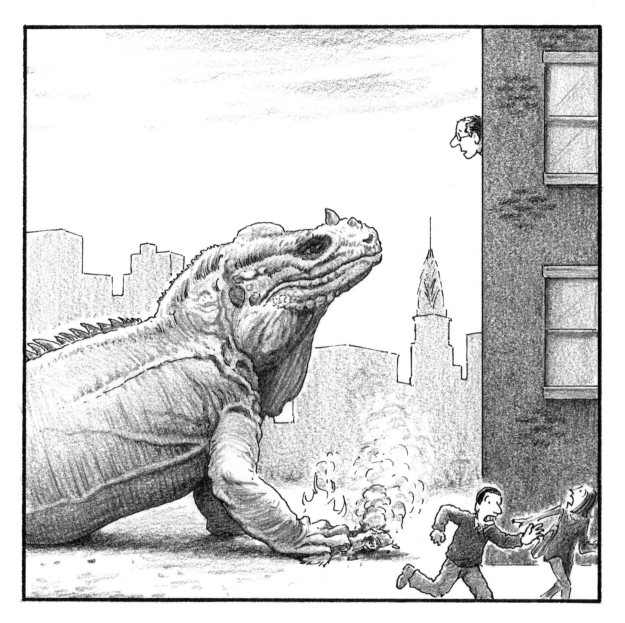

"SHE'S OFF TO COLLEGE. YOU KNEW
HER HOW MANY YEARS AGO?"

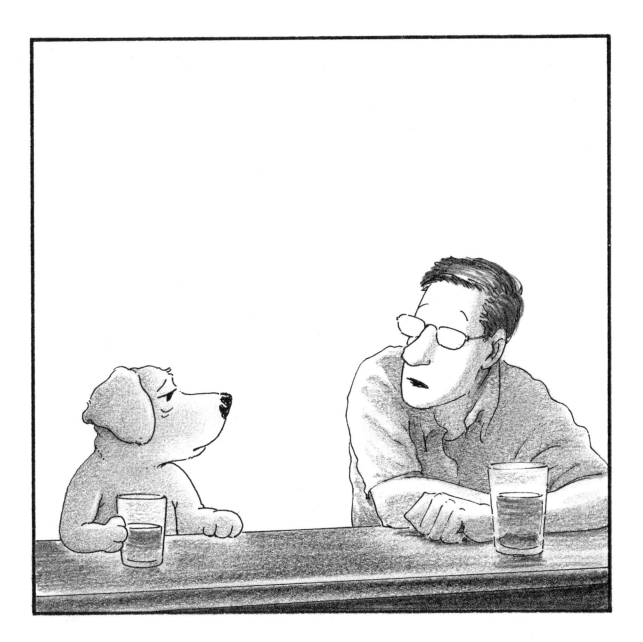

"LISTEN BUDDY, A LOT OF DOGS
ACCIDENTLY WEE–WEE AT WESTMINSTER."

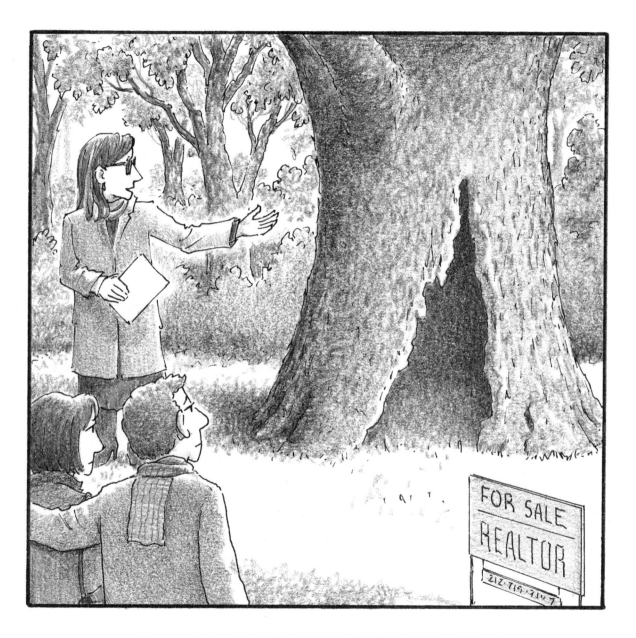

"... NOT TO MENTION THE PARK VIEW."

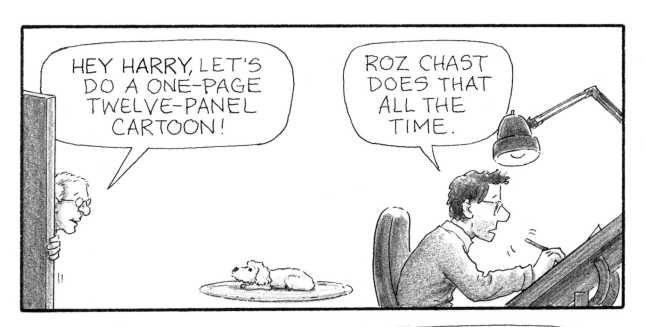

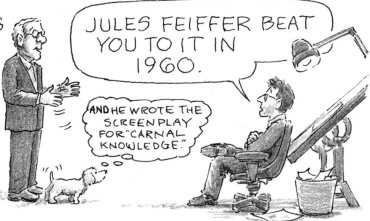

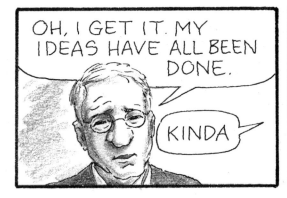

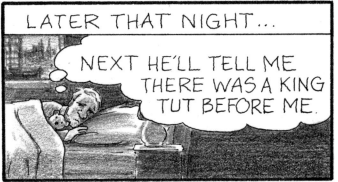

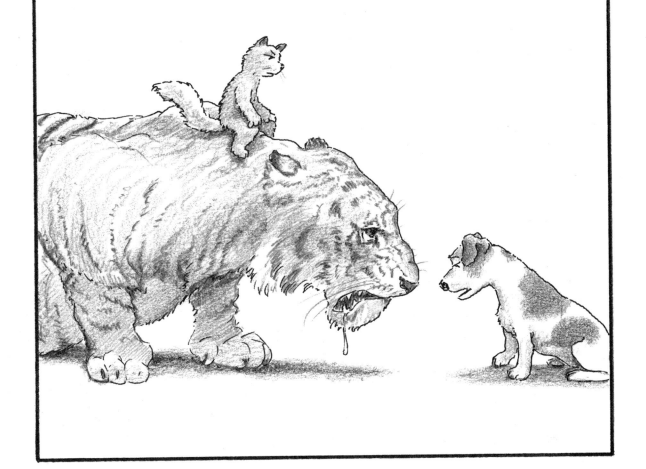

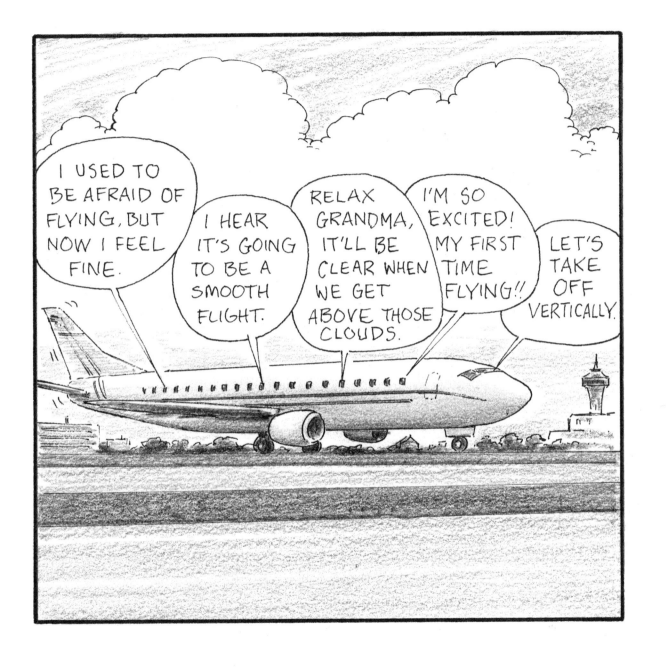

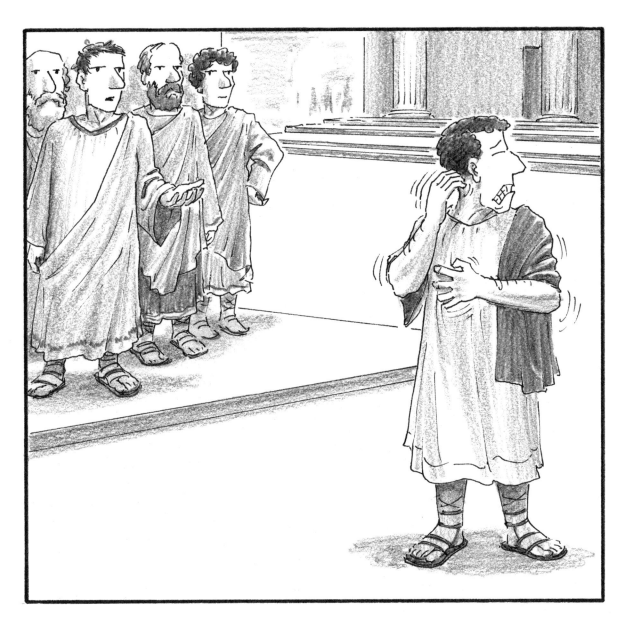

"AND WHAT SAY YOU, DERMATITIS?"

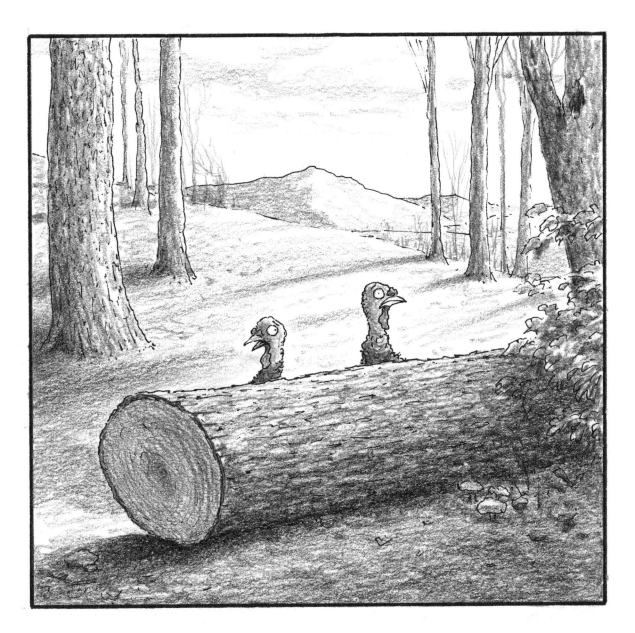

"I SMELL CRANBERRIES . . ."

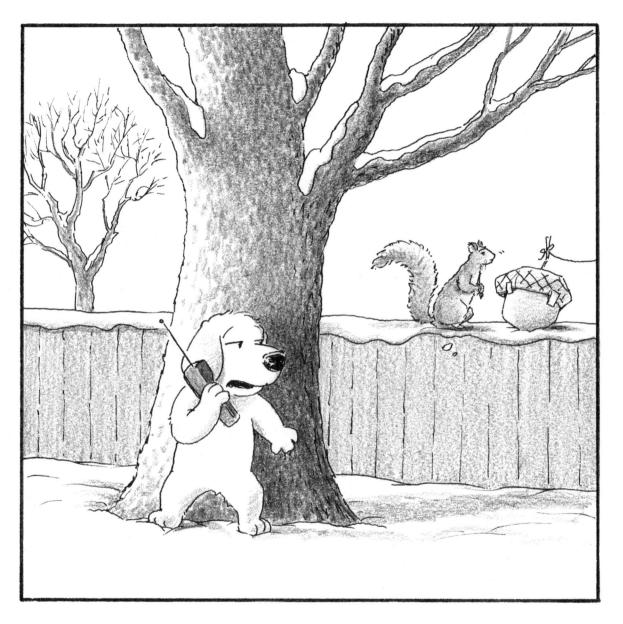

"THIS IS BLACKJACK, COME IN, YAHTZEE."

NEVER GIVE UP ON YOUR DREAMS...

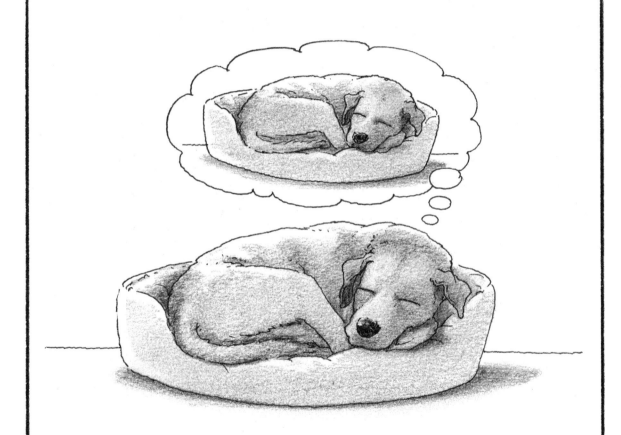

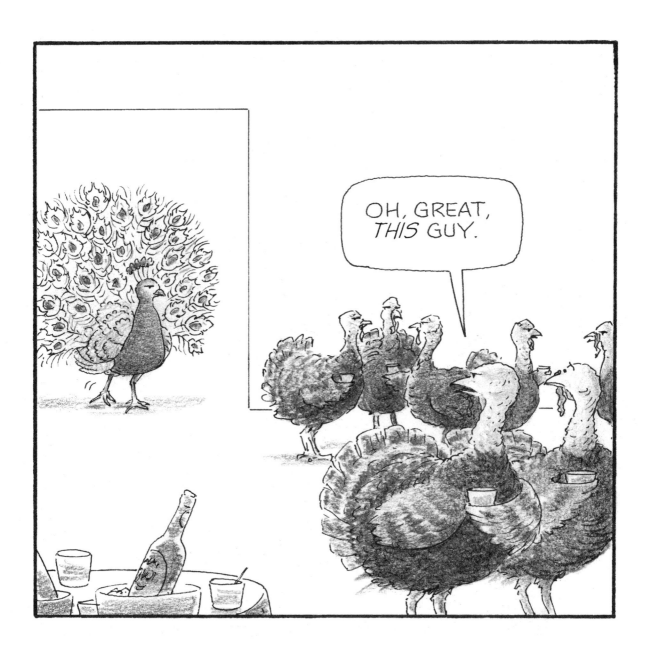

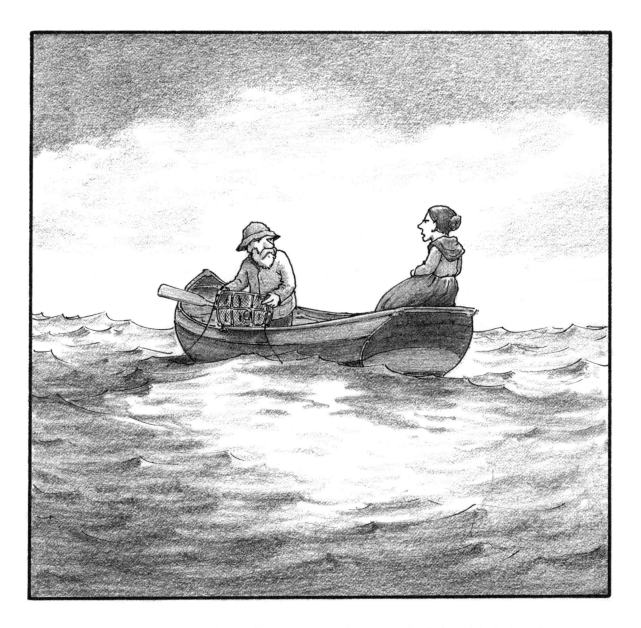

"IT'S OUR THIRD DATE. TIME FOR SOME ACTION."

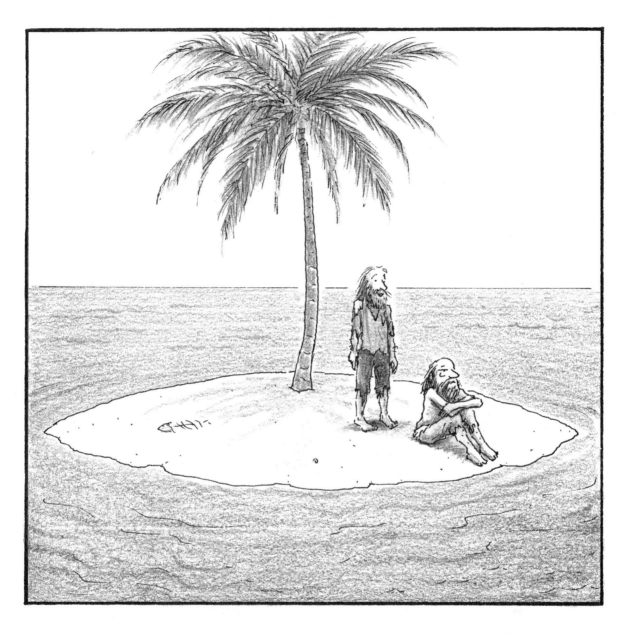

"WANNA PLAY 'WAITIN' ON THE CABLE GUY'?"

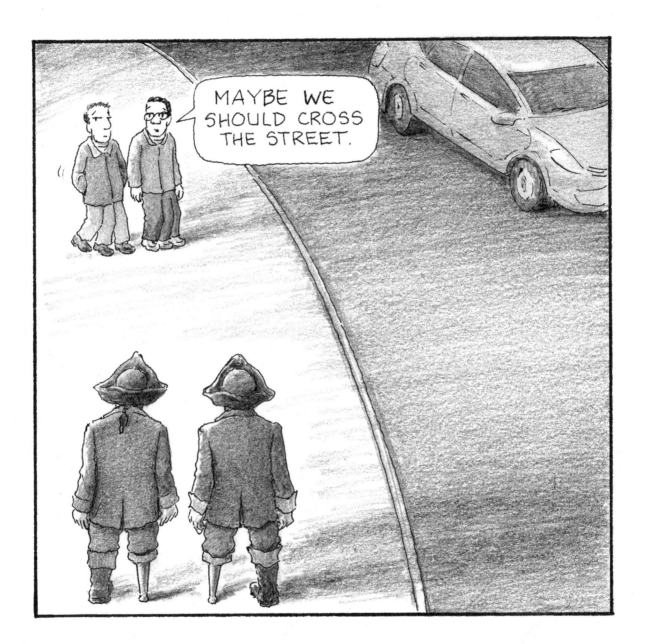

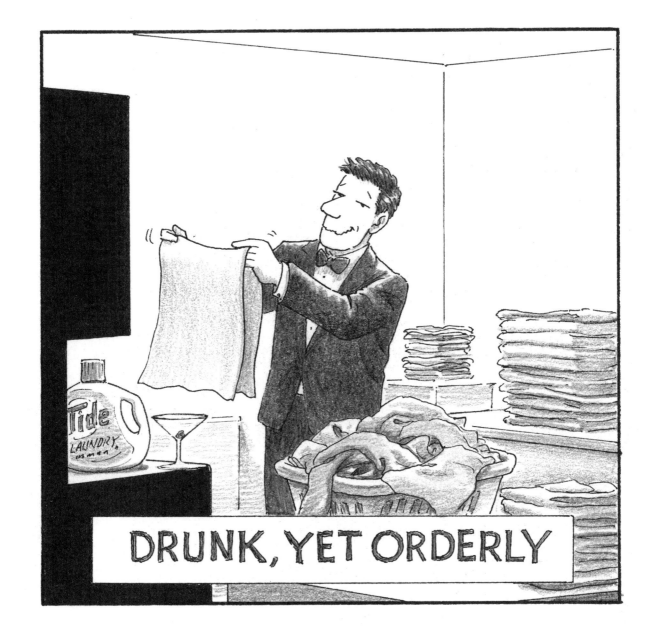

DRUNK, YET ORDERLY

"THEY FIGHT."

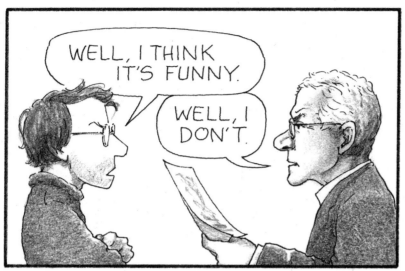

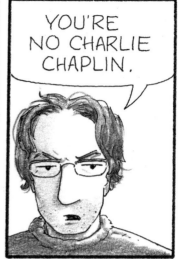

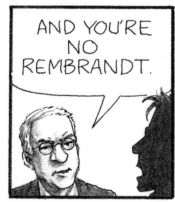

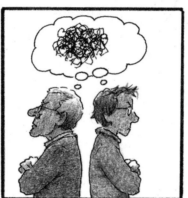

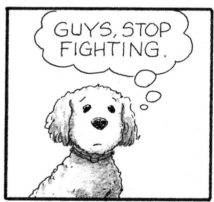

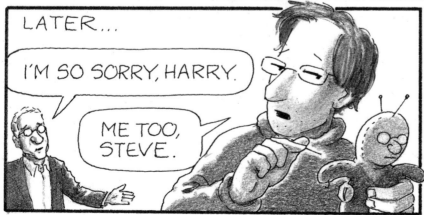

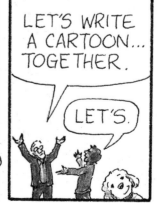

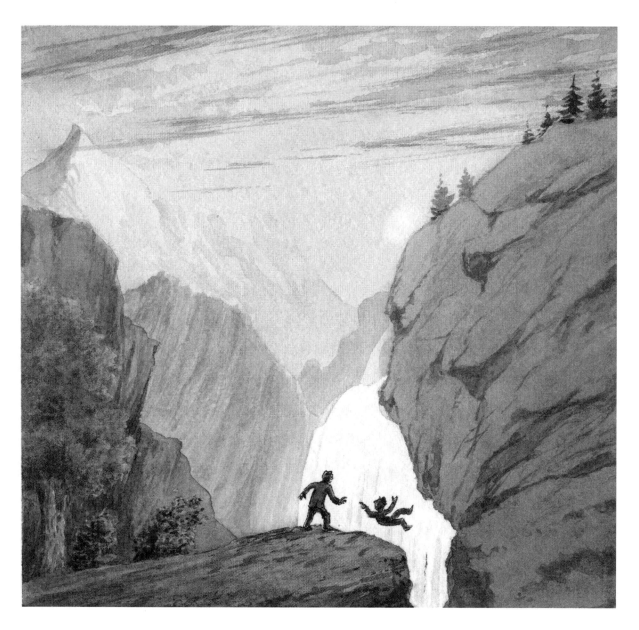

"I'LL SEE *YOU* IN ANGER MANAGEMENT CLASS!"

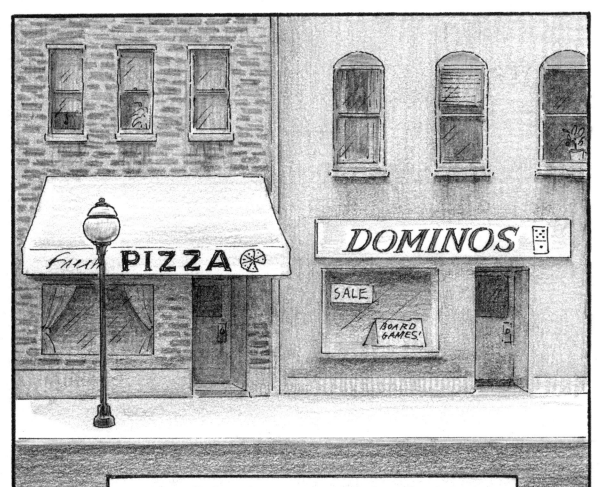

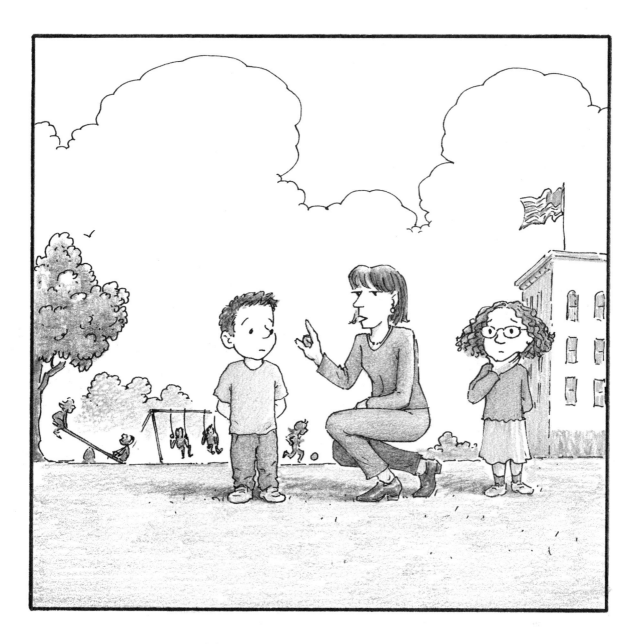

"TIMMY, WE DON'T USE THE TERM
'BRAZEN HUSSY' ANYMORE."

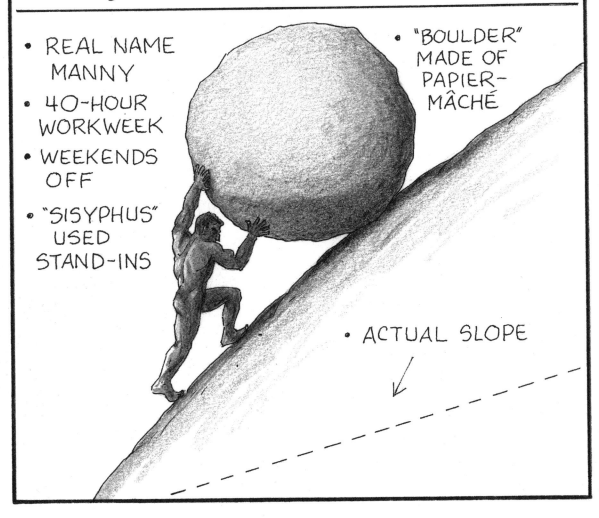

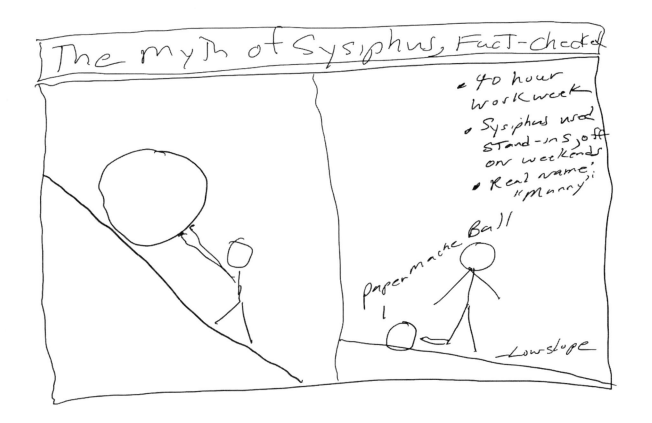

OCCASIONALLY, HARRY WILL ASK STEVE TO DRAW HIS IDEA
SO HE CAN BETTER UNDERSTAND IT.

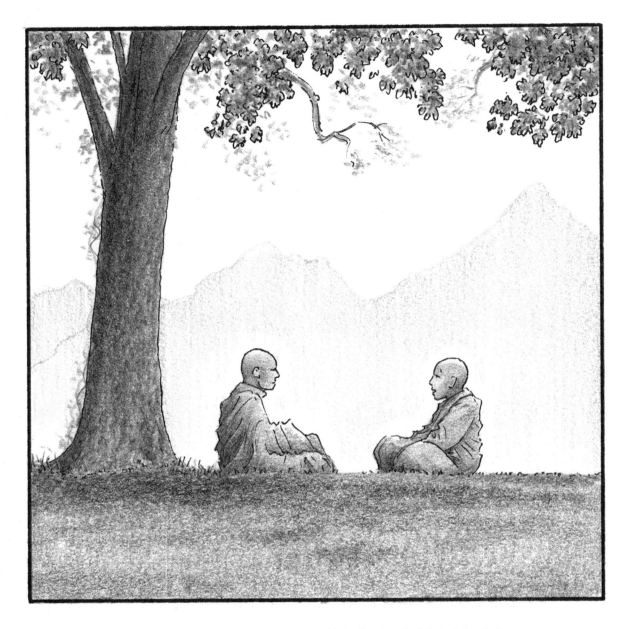

"NO, WAIT, WHAT IF THE COP CHARACTER
IS THE MURDERER AND THE MOBSTER GUY
IS COMPLETELY INNOCENT?"

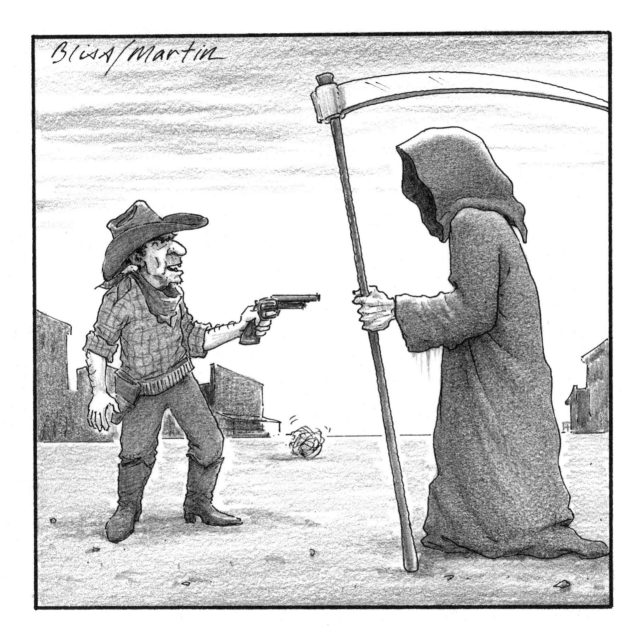

"WELL, LOOK WHO BROUGHT A KNIFE
TO A GUNFIGHT."

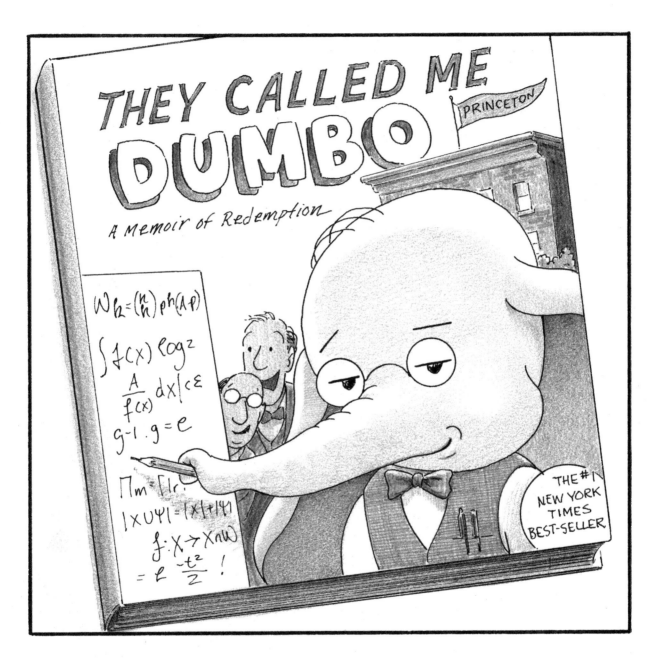

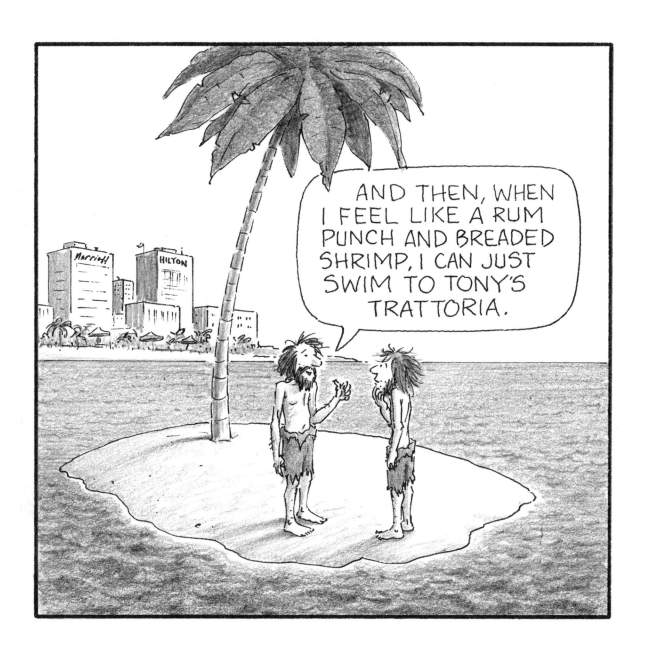

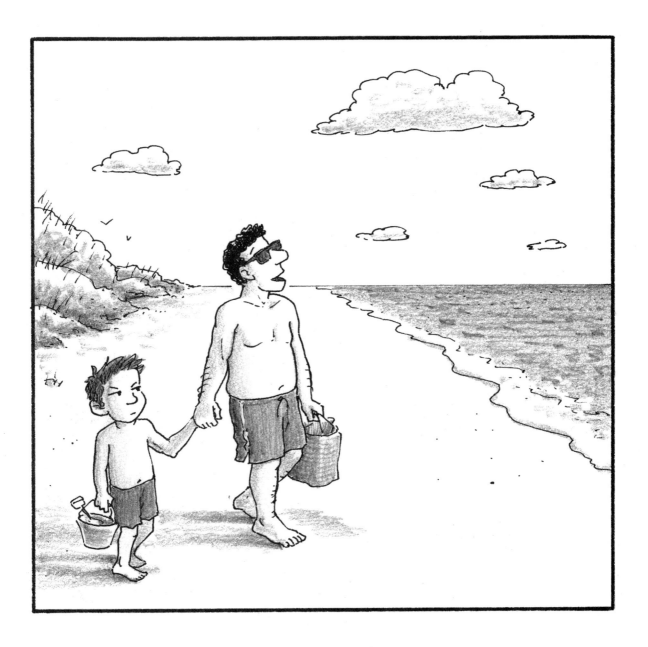

"MY FATHER USED TO BRING ME HERE WHEN
I WAS A KID, AND NOTHING'S CHANGED.
EXCEPT IT WAS A FOREST."

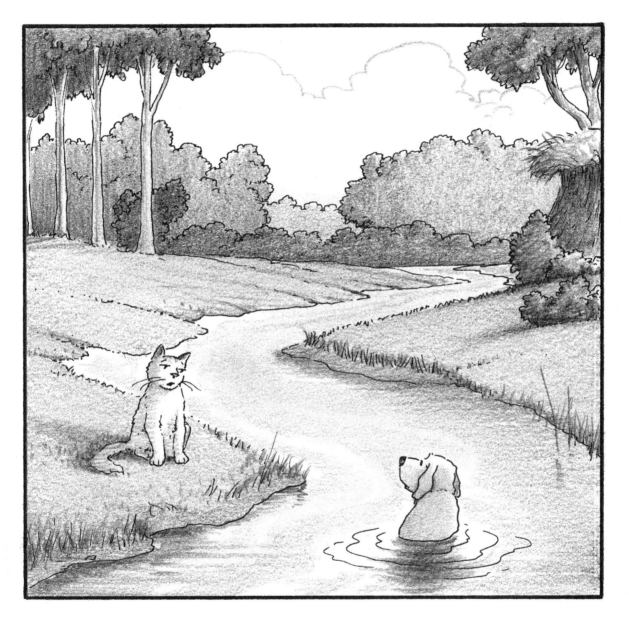

"WE'RE VERY DIFFERENT, YOU AND I,
BUT CAN WE AT LEAST AGREE ON BALLS
WITH BELLS IN THEM?"

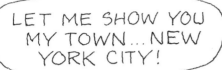

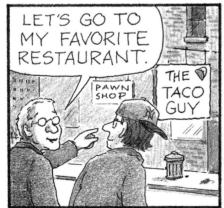

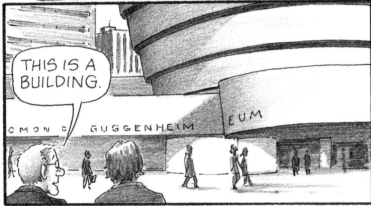

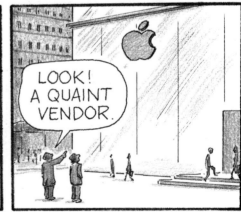

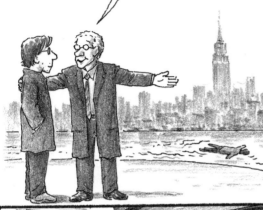

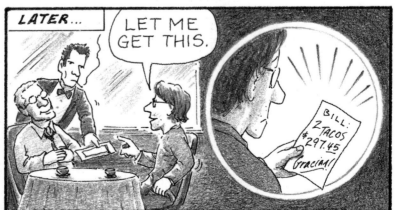

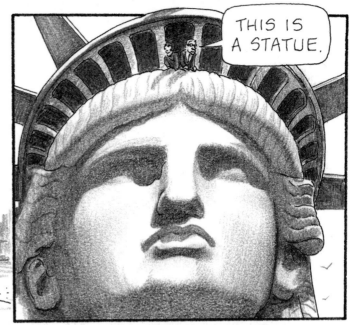

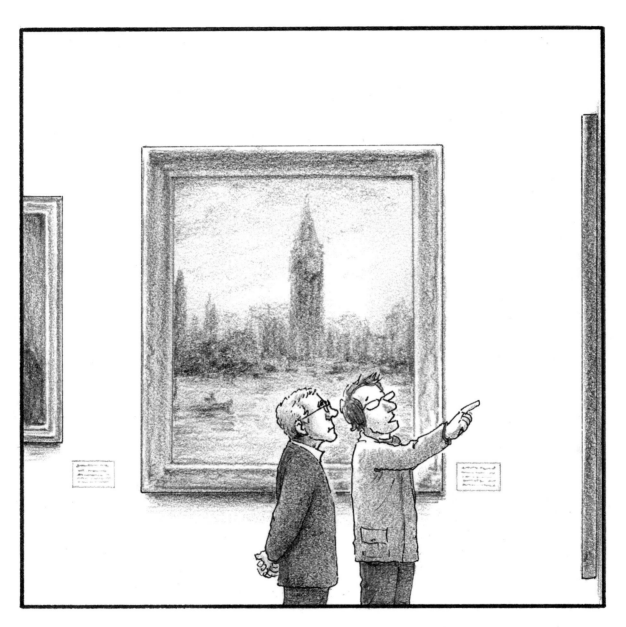

"COMPOSITIONALLY, THE FRUIT BASKET BALANCES OUT THE BEHEADING."

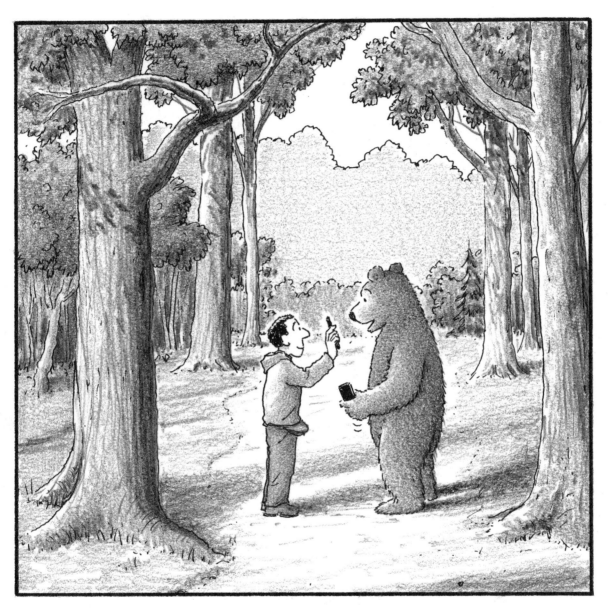

"OKAY, NOW TAKE ONE WITH MINE."

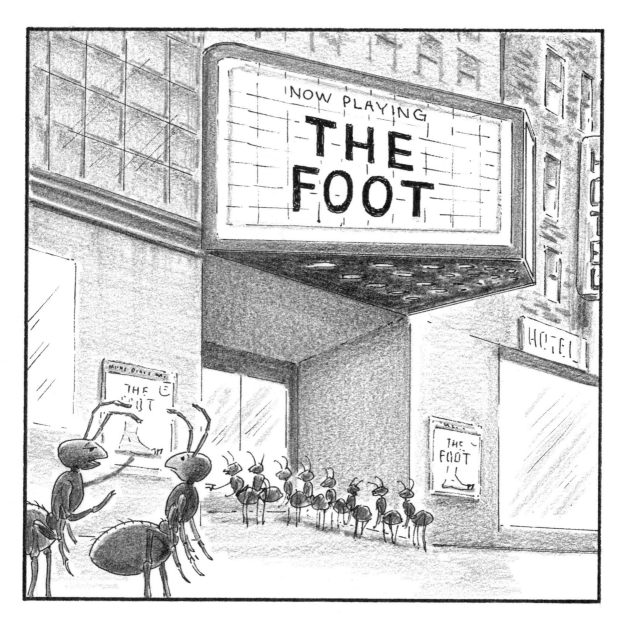

"I HEARD THIS MOVIE IS *SO* SCARY."

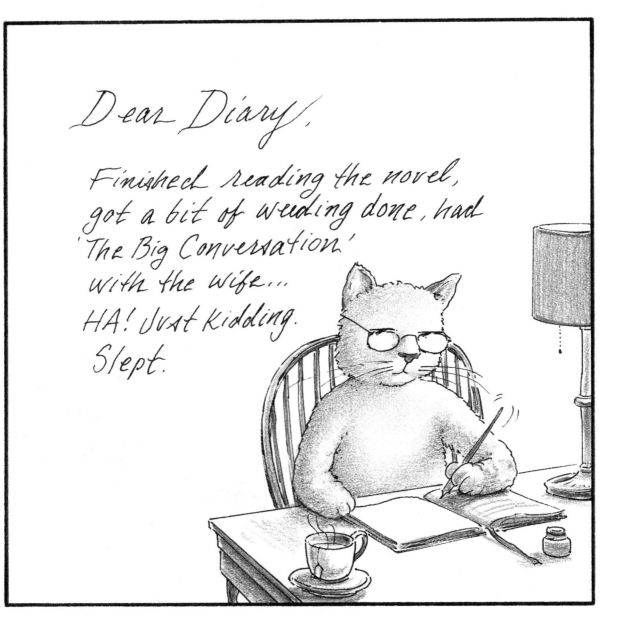

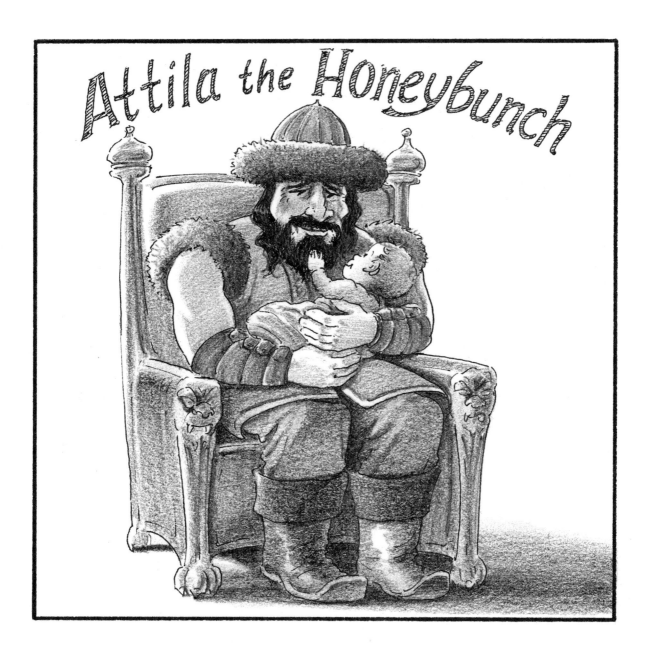

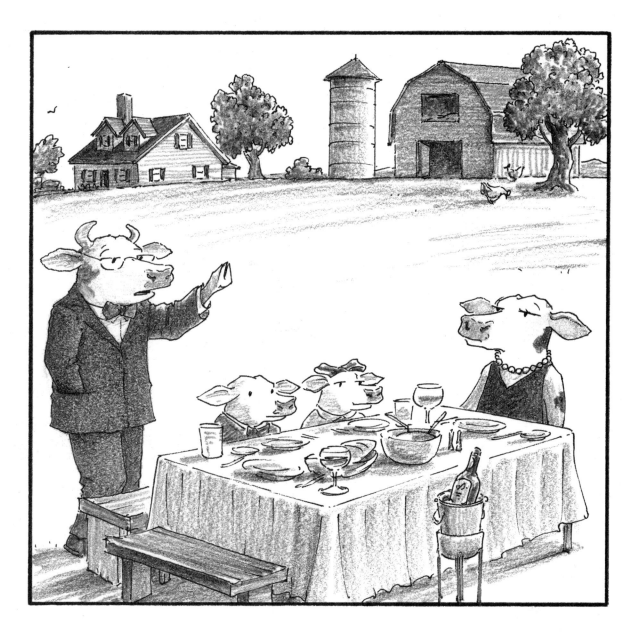

"OKAY, NOW WE'RE TOO DOMESTICATED."

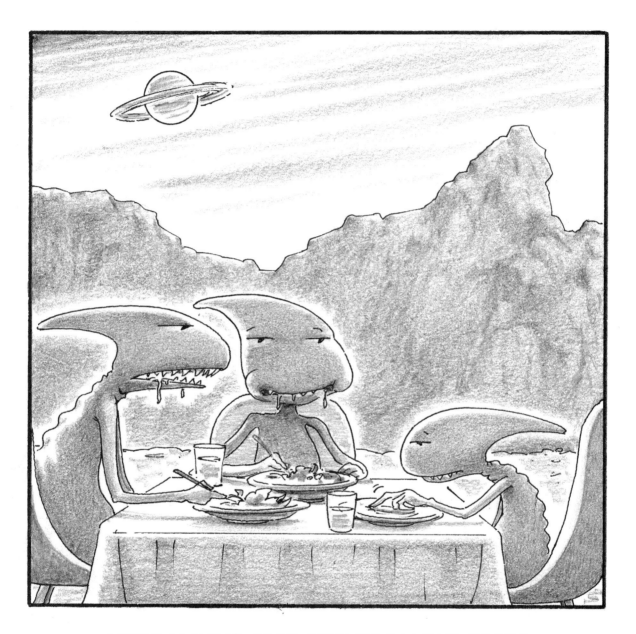

"STOP MAKING CROP CIRCLES IN YOUR FOOD."

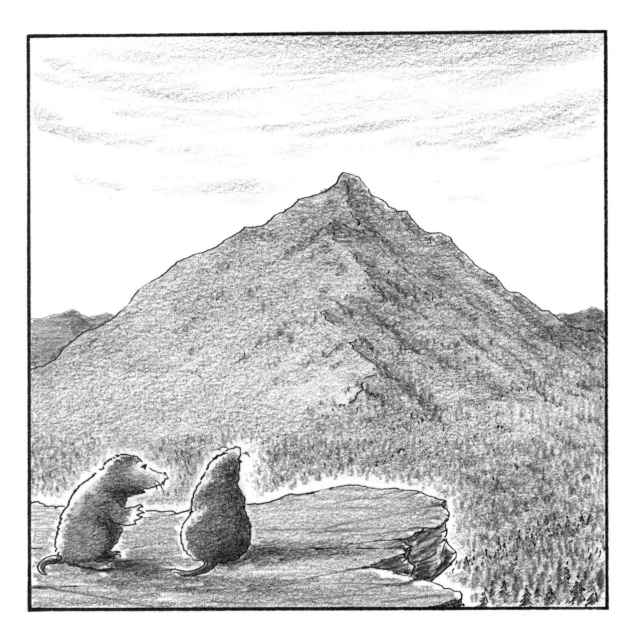

"IT STARTED OUT AS A MOLEHILL, BUT
THEN I JUST KEPT GOING."

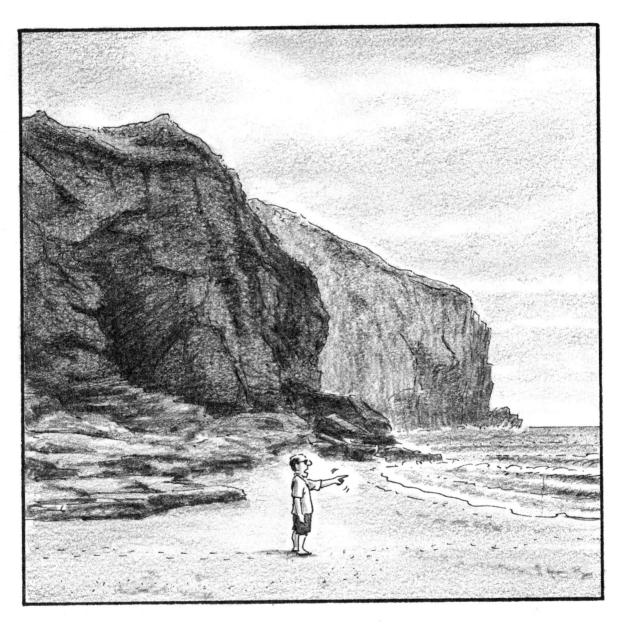

"DAMMIT, PART!"

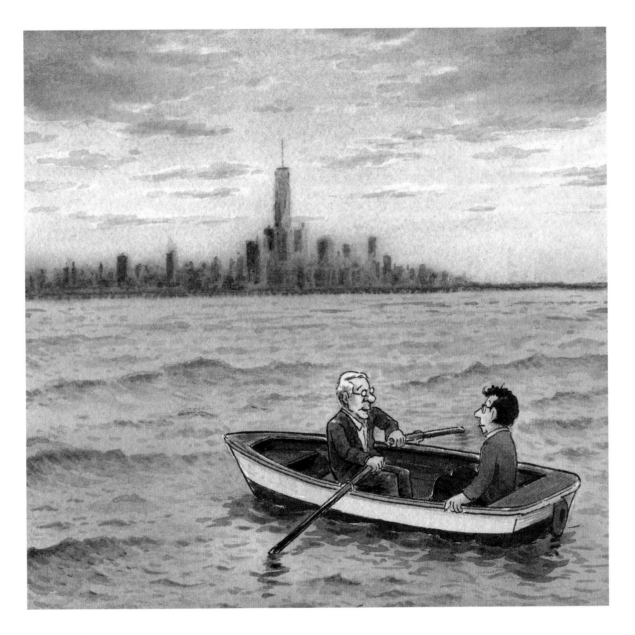

"I COME OUT HERE WHEN I WANT TO TELL
SOMEONE EVERY DETAIL OF MY LIFE STORY."

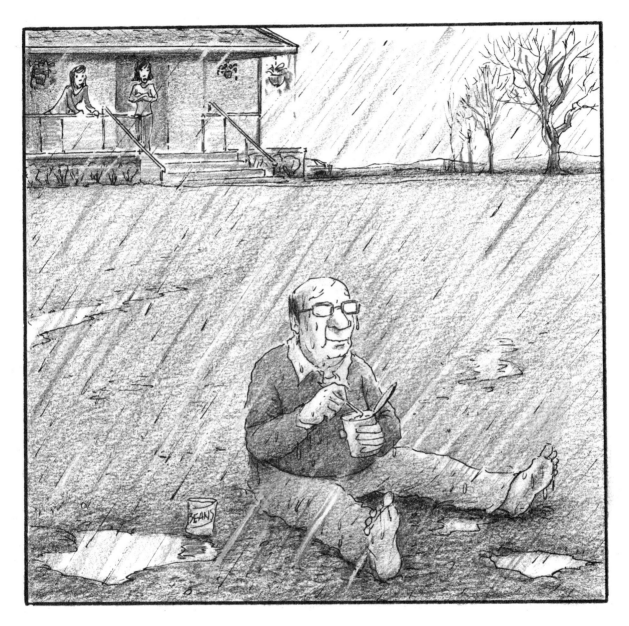

"EVERY ONCE IN A WHILE HE GETS
NOSTALGIC FOR WOODSTOCK."

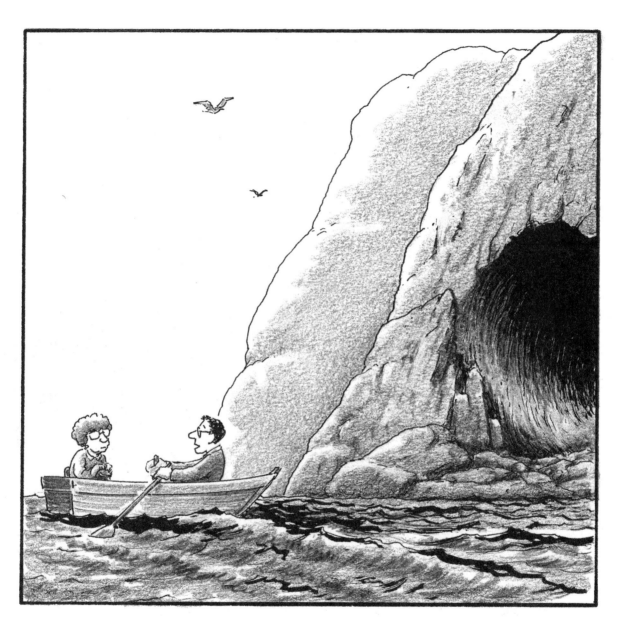

"DON'T THINK OF IT AS A CAVE,
THINK OF IT AS A RETIREMENT COMMUNITY."

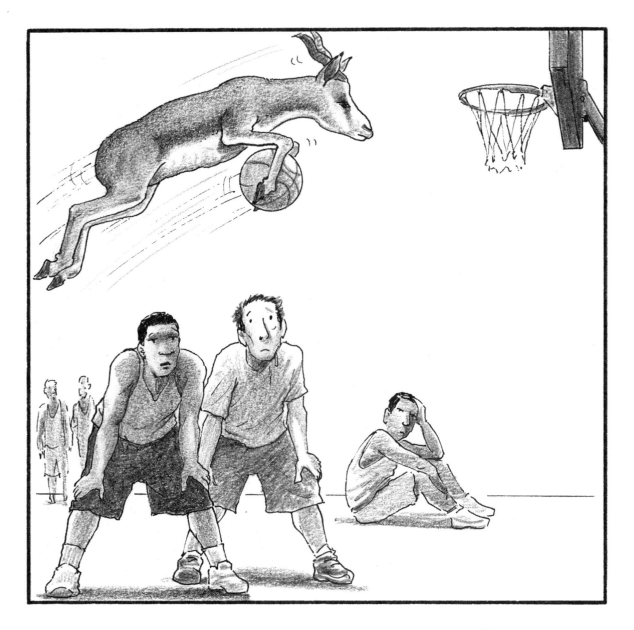

"HOW'RE WE GONNA STOP THIS GUY?"

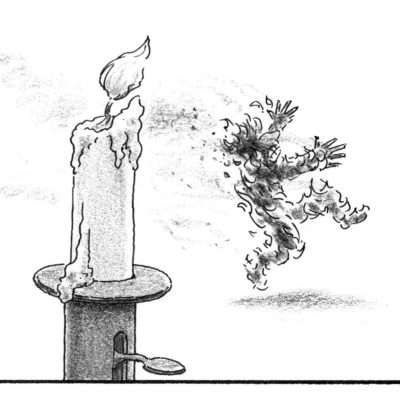

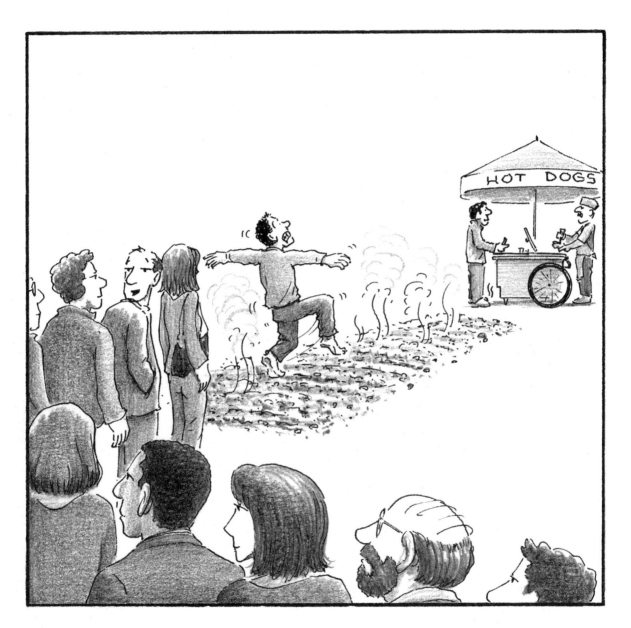

"THE BEST HOT DOGS IN THE CITY
SHOULD BE HARD TO GET."

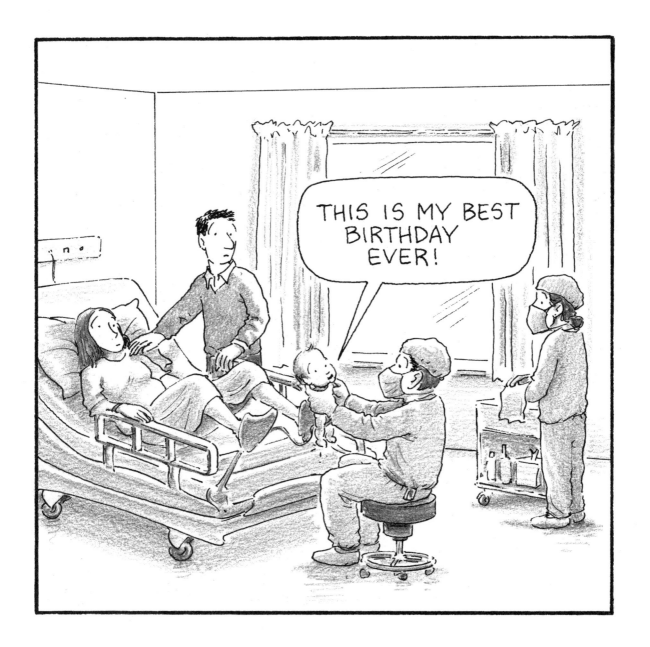

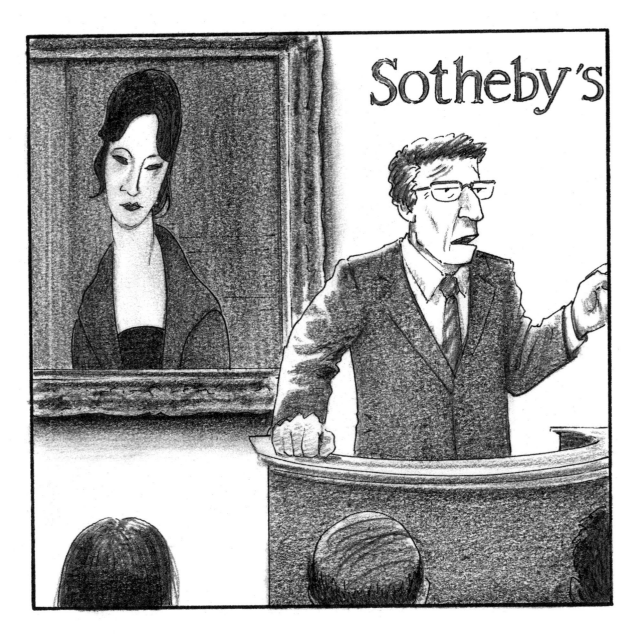

"OKAY MOFOS, LET'S MAKE DADDY HAPPY."

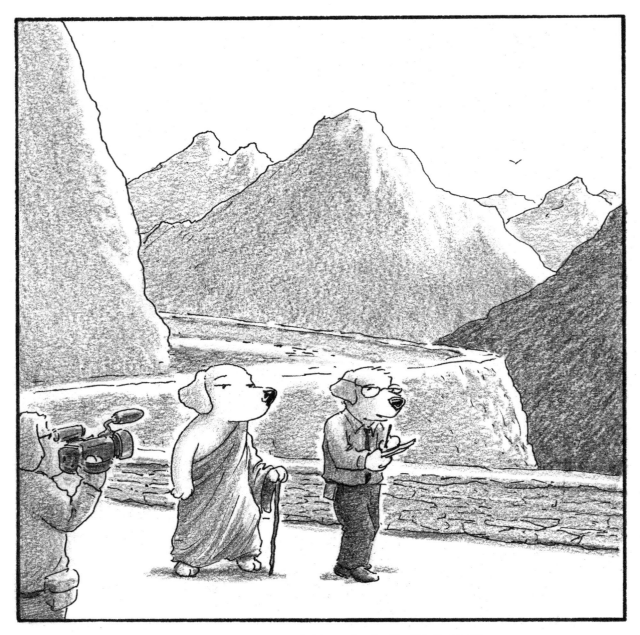

"DO YOU THINK YOU AND THE BAND
WILL EVER GET BACK TOGETHER?"

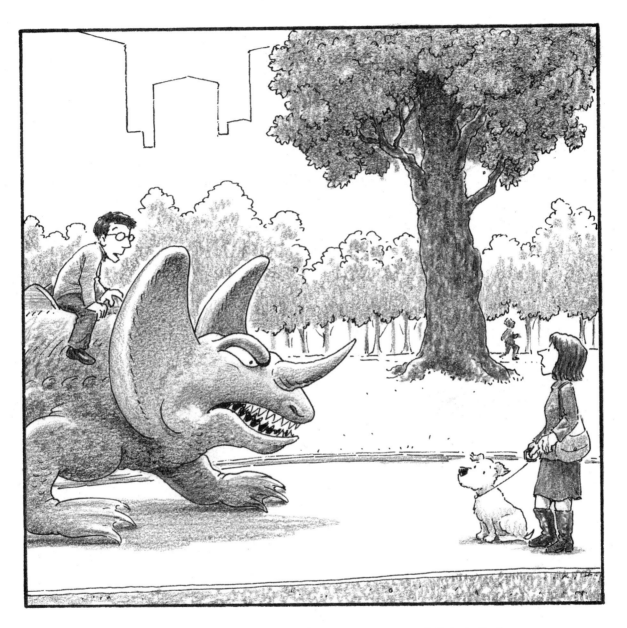

"CAN YOU DIRECT US TO THE MUSEUM OF
NATURAL HISTORY, VIP ENTRANCE?"

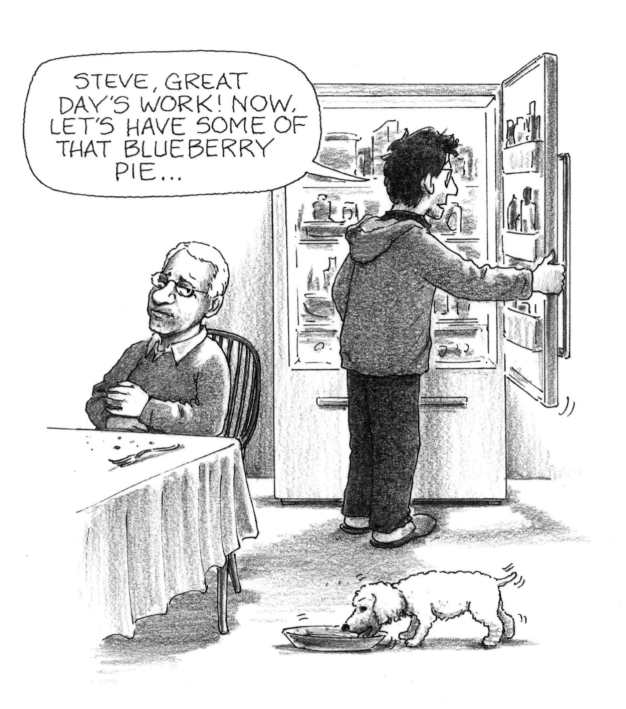

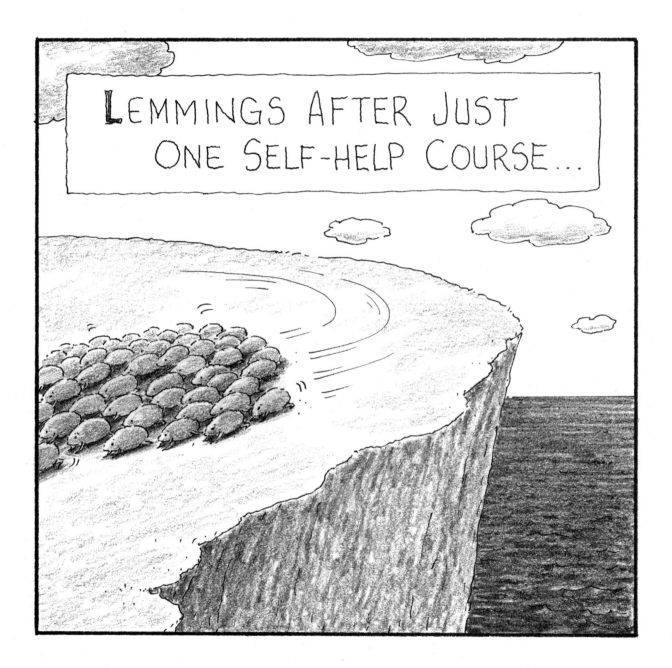

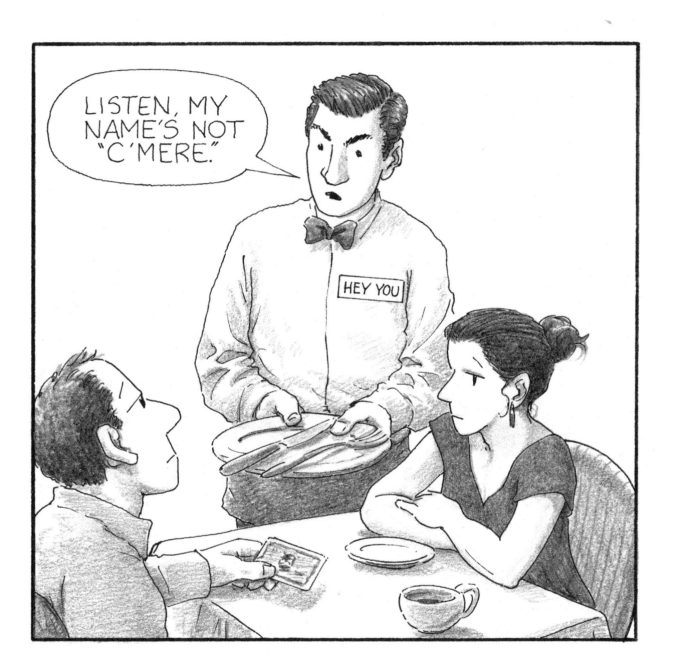

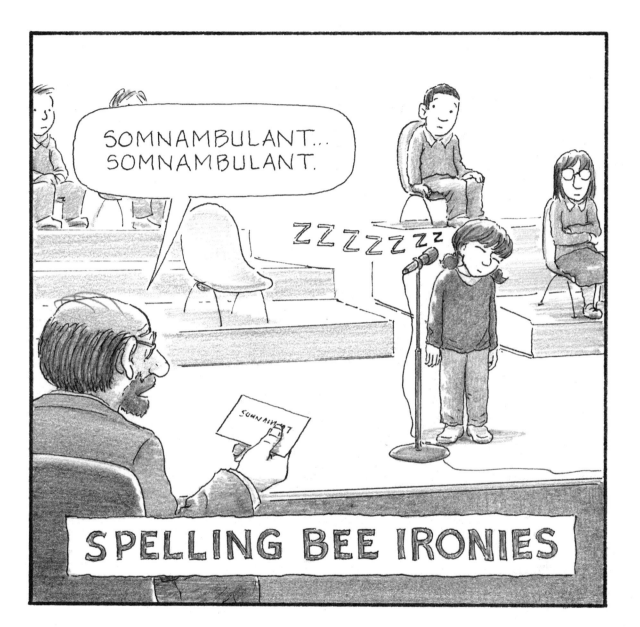

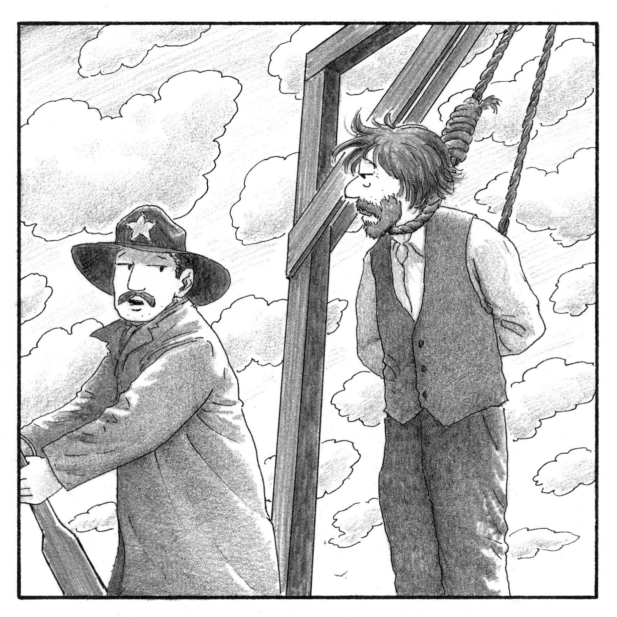

"LET'S JUST SAY WE AGREE TO DISAGREE."

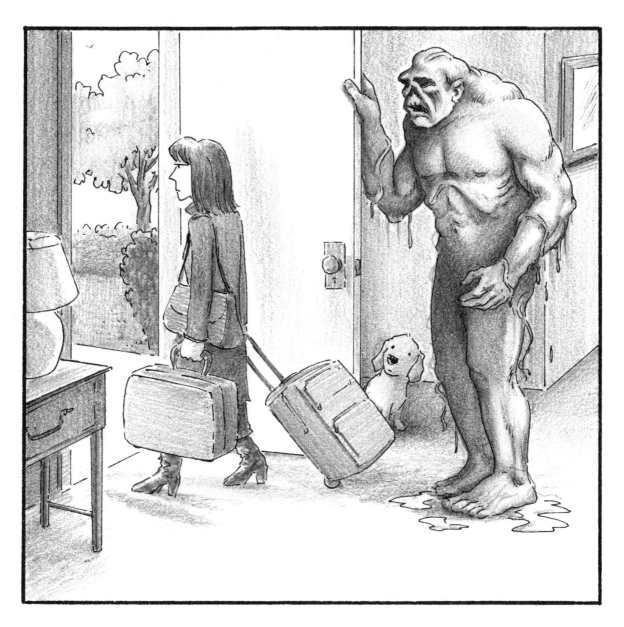

"IS IT THE SLIME?"

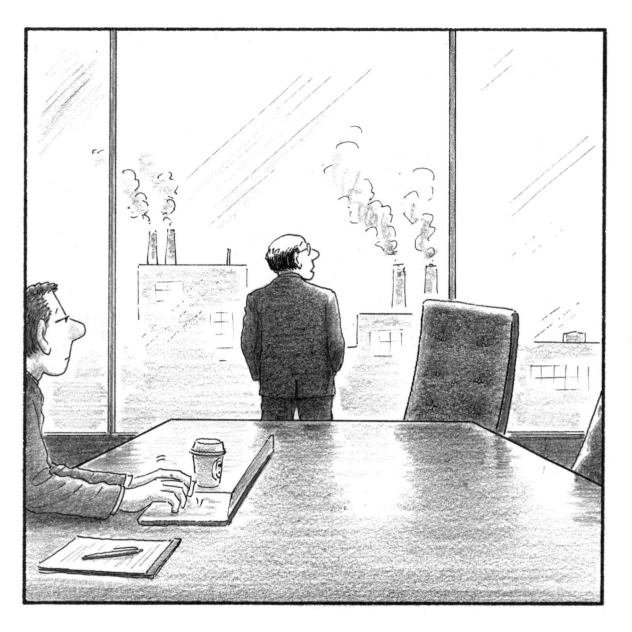

"FUNNY, I NEVER DID IT FOR THE MONEY.
I JUST ALWAYS WANTED TO MAKE T-FLANGES."

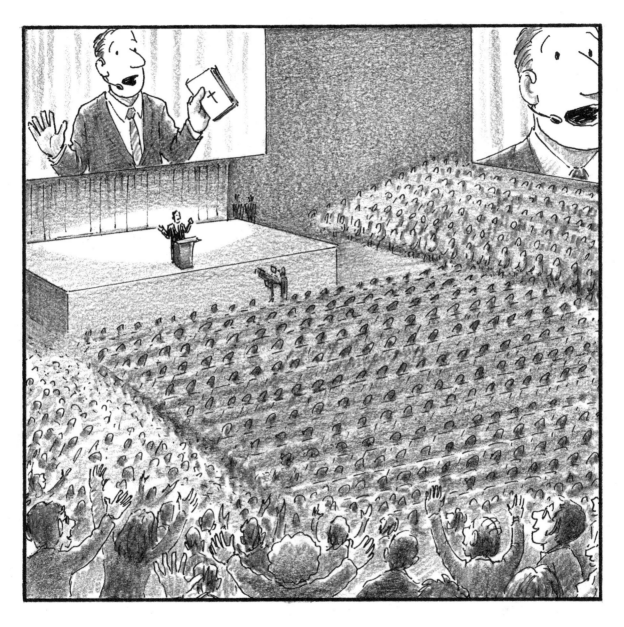

"AND THE LORD SAID, 'YOU KNOW,
IT TAKES A TON OF MONEY TO RUN A PLACE LIKE THIS.'"

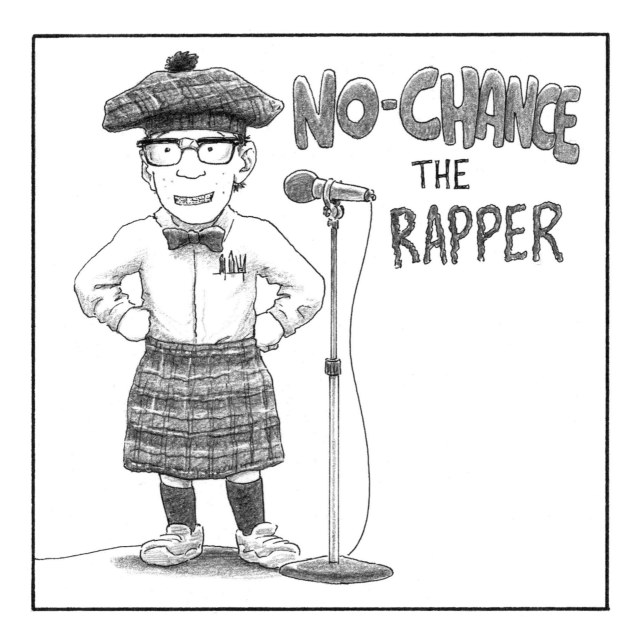

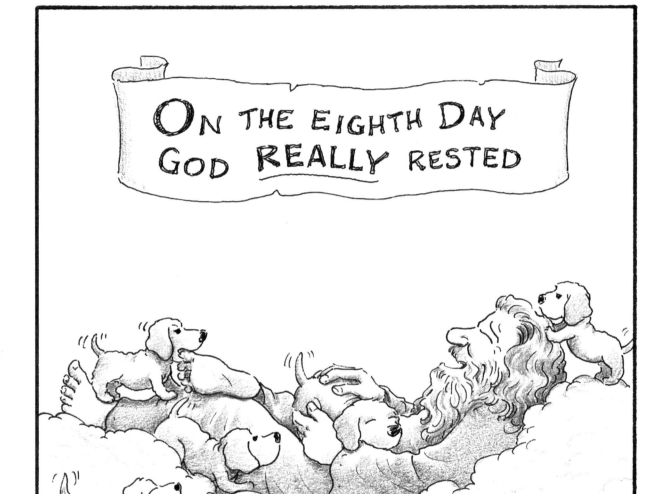

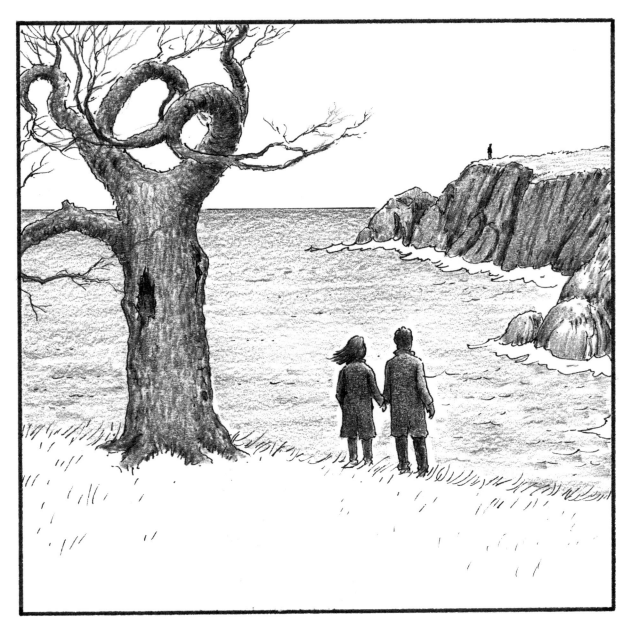

"TOO CROWDED. LET'S GO."

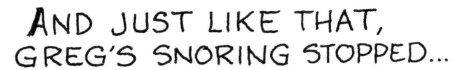

AND JUST LIKE THAT,
GREG'S SNORING STOPPED...

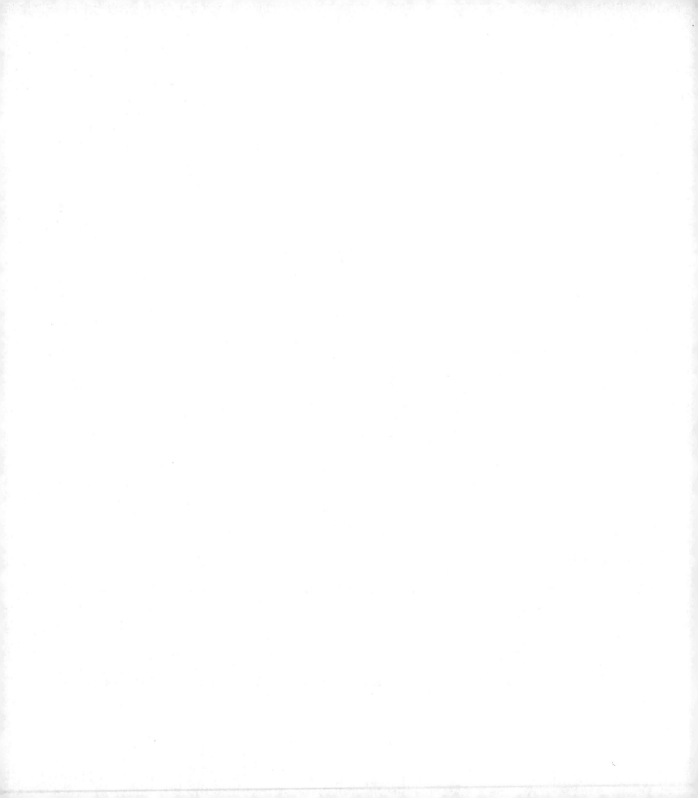

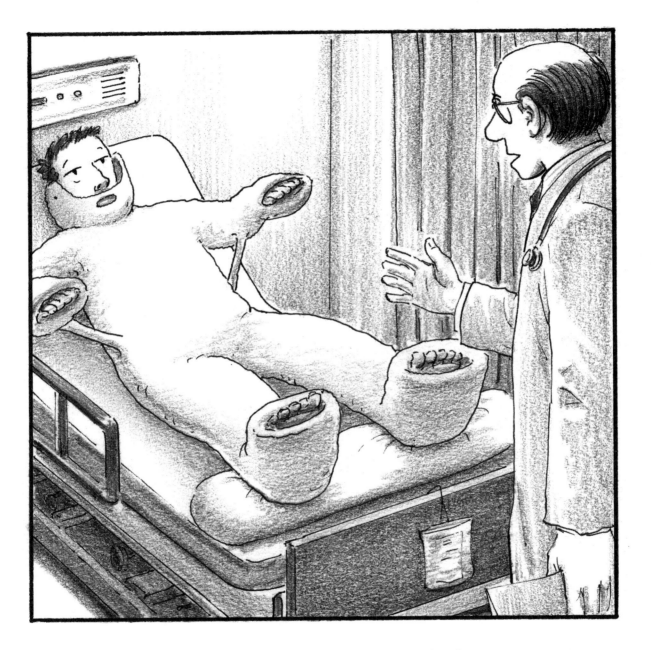

"THIS IS JUST A PLACEBO CAST,
BUT IT MAKES A LOT OF PEOPLE FEEL BETTER."

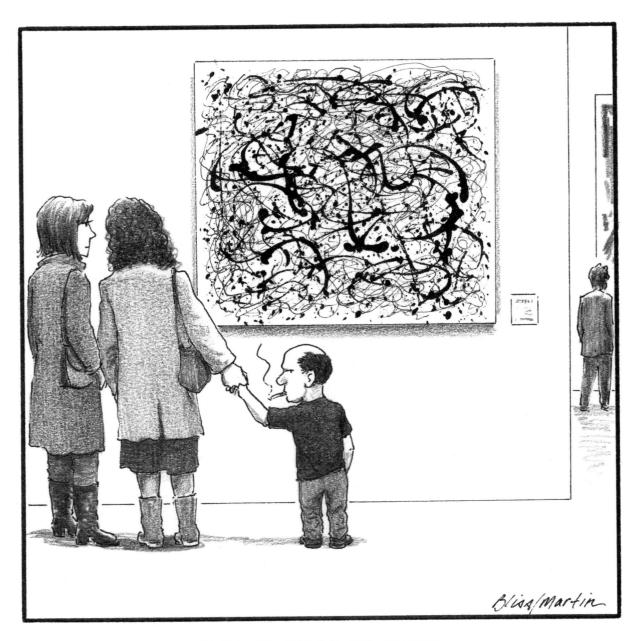

"MY KID COULD DO THAT."

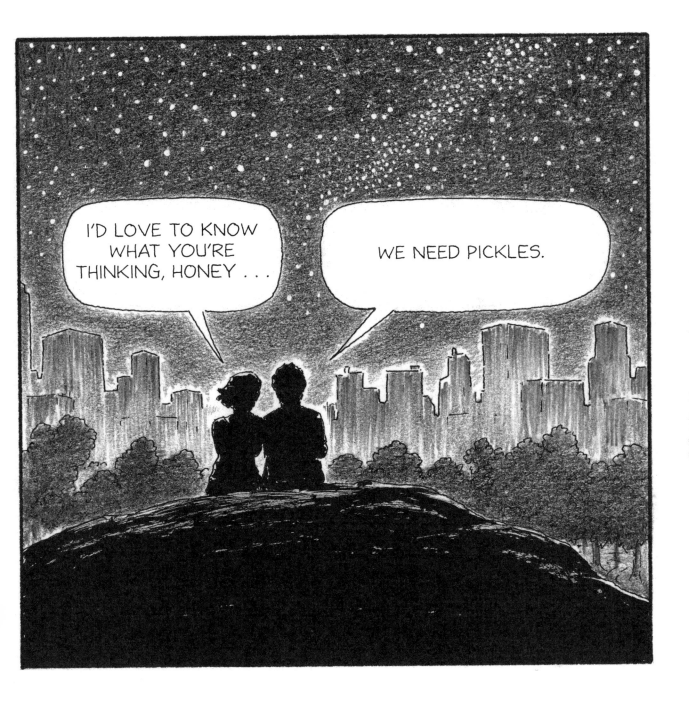

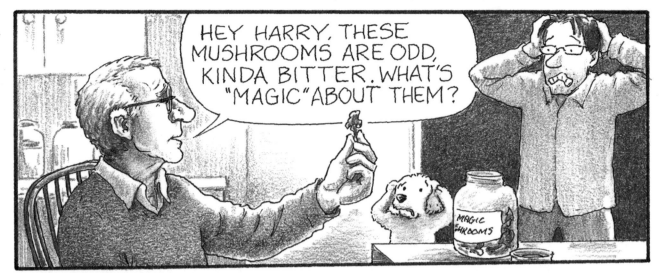

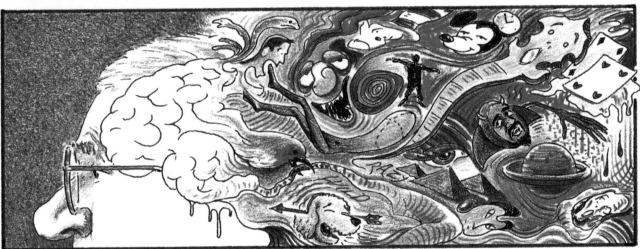

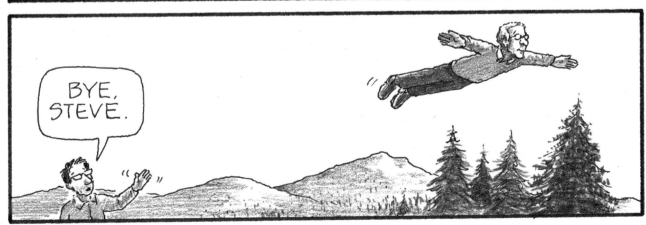

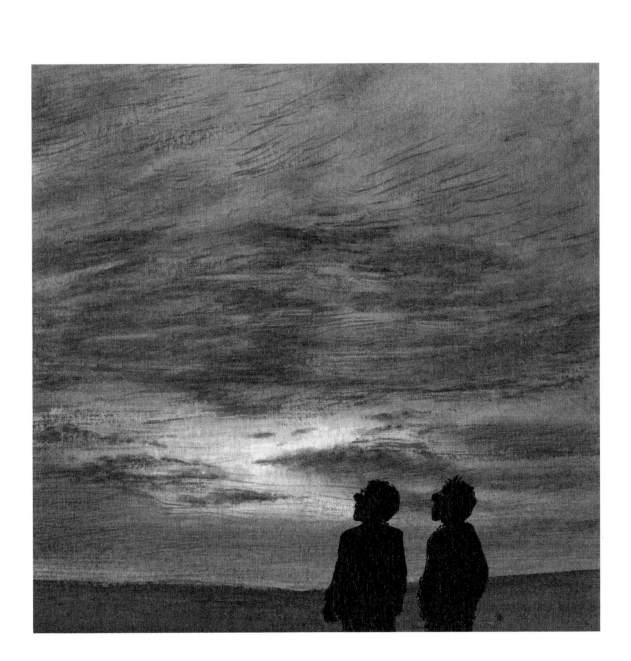

SPECIAL THANKS TO FRANÇOISE MOULY
OF *THE NEW YORKER*,
WHO VERY WISELY SUGGESTED WE GET TOGETHER.

STEVE MARTIN IS ONE OF THE MOST WELL-KNOWN TALENTS IN ENTERTAINMENT. HIS WORK HAS EARNED HIM AN ACADEMY AWARD, FIVE GRAMMY AWARDS, AN EMMY, THE MARK TWAIN PRIZE, AND THE KENNEDY CENTER HONORS. AS AN AUTHOR, MARTIN'S WORK INCLUDES THE NOVEL *AN OBJECT OF BEAUTY*; THE PLAY *PICASSO AT THE LAPIN AGILE*; A COLLECTION OF COMIC PIECES, *PURE DRIVEL*; A BESTSELLING NOVELLA, *SHOPGIRL*; AND HIS MEMOIR, *BORN STANDING UP*. MARTIN'S FILMS INCLUDE *THE JERK*; *PLANES, TRAINS AND AUTOMOBILES*; *ROXANNE*; *PARENTHOOD*; *L.A. STORY*; *FATHER OF THE BRIDE*; AND *BOWFINGER*.

HARRY BLISS IS A CARTOONIST AND COVER ARTIST FOR *THE NEW YORKER* MAGAZINE. HIS SYNDICATED SINGLE-PANEL COMIC *BLISS* APPEARS IN NEWSPAPERS INTERNATIONALLY. HE HAS WRITTEN AND ILLUSTRATED MORE THAN TWENTY BOOKS FOR CHILDREN AND IS THE FOUNDER OF THE CORNISH CCS RESIDENCY FELLOWSHIP FOR GRAPHIC NOVELISTS IN CORNISH, NEW HAMPSHIRE. VISIT HIS WEBSITE AT WWW.HARRYBLISS.COM.

CELADON
BOOKS
———
NEW YORK

FOUNDED IN 2017, CELADON BOOKS,

A DIVISION OF MACMILLAN PUBLISHERS,

PUBLISHES A HIGHLY CURATED LIST

OF TWENTY TO TWENTY-FIVE NEW TITLES A YEAR.

THE LIST OF BOTH FICTION AND NONFICTION IS ECLECTIC

AND FOCUSES ON PUBLISHING COMMERCIAL AND

LITERARY BOOKS AND DISCOVERING

AND NURTURING TALENT.

...T at 10 am or earlier, maybe
arrived around 11 am and
a fire. A grey + rainy day
so, sleeting rain/snow — a
day to remain inside doing
ly what I plan to do —
cartoons and read. I'll
ss the next spread for 'Jerry'
ow.
y sent 2 ideas, no 3, today.
all pretty good, 2 are
ood.

**MY PARENTS NAMED
ME DOPEY**
A MEMOIR OF SADNESS

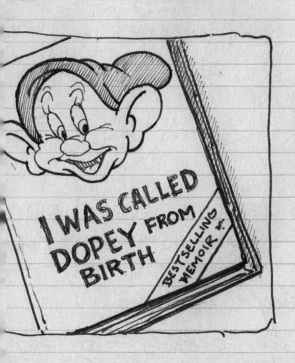

I WAS CALLED
DOPEY FROM
BIRTH
BESTSELLING MEMOIR

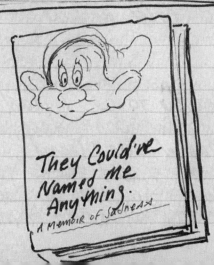

They Could've
Named Me
Anything.
A MEMOIR of SADNESS

These are 2 drawings based on
an email Steve had sent me.
This caption (below) is what Steve
wrote
back after
I sent him
a rough —
he was
going to
look at it.
His response
sounded
like a
cartoon
caption

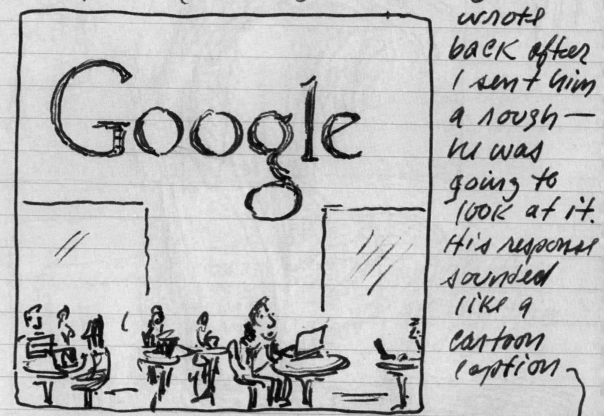

"HOLD ON, STILL DOWNLOADING.
THE INTERNET IS REALLY SLOW HERE."

So, I mentioned this to him, ask
ing for a visual — he gave me
Neptune and the guy above.